22.50

Ew.

D1586813

Barbara Hepworth

Barbara Hepworth

Sculptures from the Estate

ESSAY BY ALAN G. WILKINSON

OCTOBER 8 - NOVEMBER 16, 1996

WILDENSTEIN

19 EAST 64TH ST NEW YORK NY 10021

A note on the Hepworth sculpture from the Estate

Most of the sculptures in this exhibition come from the Estate of Barbara Hepworth, who died 21 years ago at the age of 72. Throughout her life she had kept back certain key works which she regarded as reference points in her career, and she retained all the artist's copies of her bronzes, except for a few which were given to public museums, or to friends, or to charitable causes.

After her death, and following her wishes, Sir Norman Reid (a co-Trustee of the Estate, and my predecessor as Director of the Tate Gallery) and I were able to make a fully representative choice of some forty works to establish the Barbara Hepworth Museum in the artist's former home and garden at St. Ives in Cornwall. This was run at first as a private museum, and then in 1980 given by the artist's daughters into the care of the Tate Gallery.

We have also placed many of the largest bronzes in appropriate open-air sites in Britain, notably at the Yorkshire Sculpture Park, in Hepworth's native city of Wakefield, at Snape Maltings (fulfilling a wish of her friends Benjamin Britten and Peter Pears), in Edinburgh, at several Cambridge colleges and at other UK campus sites.

In the catalogue which I made of Hepworth's oeuvre there is a total of 579 sculptures, made over a working career of exactly fifty years—an average of fewer than 12 sculptures a year. When she began to work in metal in 1956, her rate of production increased slightly, and of course there were now editions of bronzes which more than doubled the number of sculptures by Hepworth. In the 1950s and 1960s she was at the peak of her career, internationally recognized after her Venice Biennale success in 1950, and working with great strength and confidence. She accepted several major commissions, including *Single Form*, the memorial for her friend Dag Hammarskjöld at the United Nations, but was often not happy with commissioned work and did not seek it.

Hepworth was, and always remained, a carver. She loved to shape the wood or stone with the tools in her own hands. She made very few drawings for sculpture, or maquettes (unlike Henry Moore) because she always said that she could envisage the form when she looked at the block of wood or stone. An assistant would help with the rough work, but then she took over. She had a special affinity for the material of her sculpture, responding to the organic nature of wood with its innate quality of tree growth. Each stone also had its color and texture, and its sense of growth, albeit infinitely slow.

She always continued to carve (three quarters of her 579 works are carvings) but just over halfway through her career, in the mid 1950s, she began working in bronze as well. There were several reasons for this. She sensed the fragility and the limitations of wood and stone, and wanted to work on a larger scale. She had also come to feel that her sculpture was often best seen in an outdoor land-scape or garden setting, and bronze alone is suitable for this. (Conservators now warn that few stone sculptures should remain exposed to the open air, whereas outdoor bronzes often improve with age).

Hepworth's bronze sculptures are either versions of carvings, translated into a more permanent material, or what she called "free forms" which can only exist in the medium of bronze. The possibilities of the material fascinated her—she found that she could make forms that were more open and fluid than anything she had done in wood or stone. Cutting and bending a sheet of metal and stringing it was a part of the constructivist element in her work—she had after all been a close friend and associate of Gabo who lived in Hampstead and St. Ives in the 1930s and 1940s. And then she found a way of making the bronze without modeling—first constructing an armature, and then building up and carving down the plaster until she reached the shape and surface she required. She loved the color of the eventual bronze, and the variety of patination that was possible, sometimes varying the casts in a single edition. The bronzes were always returned to her from the foundry, and often worked on in the studio until she was satisfied. Like Moore, she was adamant that there should be no posthumous casts of her work, and incomplete editions were left unfinished.

In the final years of her life she was exploring the possibilities of multipart sculpture, often constructed out of discrete parts and not always constricted by one definitive arrangement. The nine part *Family of Man* (1970) is the major example of this new development, presented either as a group or as separate figures. It was followed by the *Conversation with Magic Stones* and the two multipart marble groups, *Assembly of Sea Forms*, and *Fallen Images* that are now in the Norton Simon Museum in Pasadena and the Hepworth Museum, St. Ives.

In the studios at the Hepworth Museum at St. Ives, left essentially just as they were on the day she died in May 1975, are more ideas for multipart sculptures that were never to be realized, and single pieces that she never finished. The last years of Hepworth's life were hampered by ill-health, and she was finding it increasingly difficult to continue carving. She had lived for her work—her lifestyle was always very simple. She had a real sense of her own achievement, made in not the easiest of personal and historical circumstances. At the end she was happy and content to think that she had been able to make a distinctive contribution to the art of her century.

Alan Bowness, St. Ives, August 1996

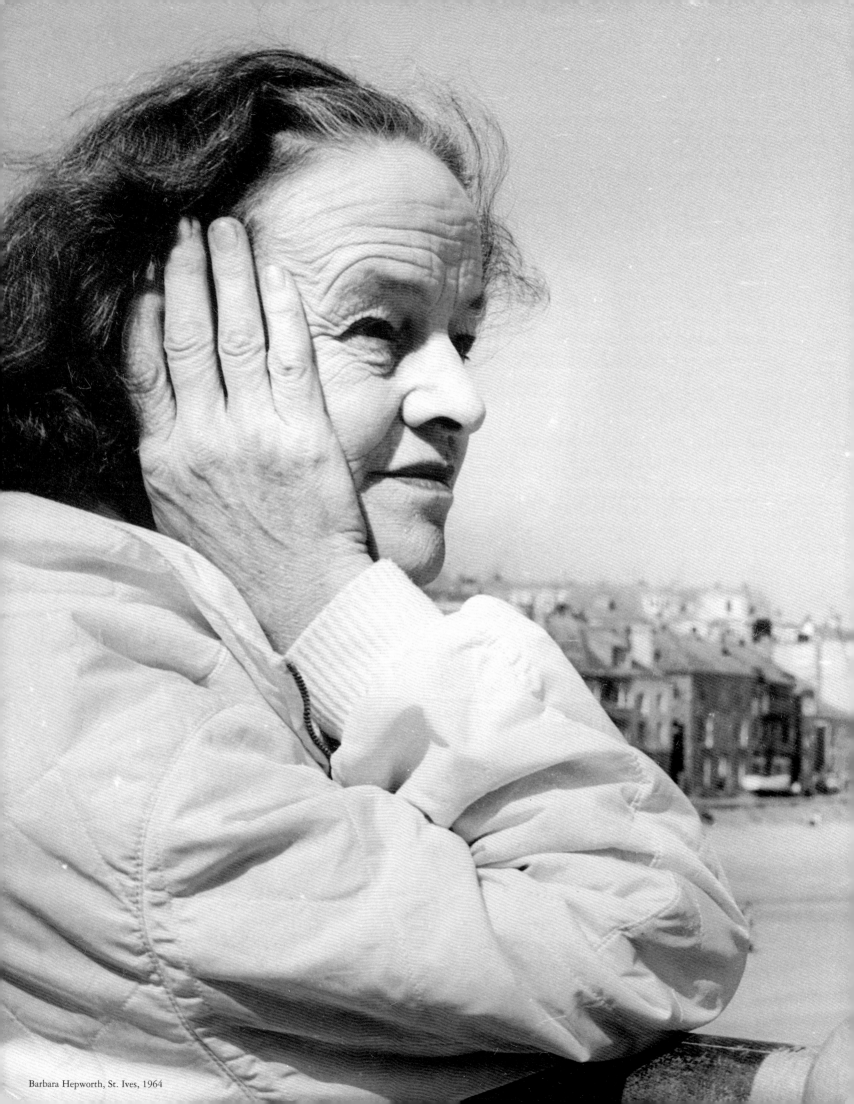

Barbara Hepworth, St. Ives, 1964

"The stone in my hand
IS my hand"

–Anne Wilkinson, "Poem in Three Parts"

Mathematics possesses not only truth, but supreme beauty—a beauty cold and austere, like that of sculpture, without appeal to any part of our weaker nature, sublimely pure and capable of a stern perfection such as only the greatest art can show.

–Bertrand Russell, *The Study of Mathematics*

In his article "Art and the Scientist," published in *Circle: International Survey of Constructive Art* (1937), the distinguished British physicist J.D. Bernal discussed and illustrated the remarkable affinities between Barbara Hepworth's sculpture and mathematical forms: "There is an extraordinary intuitive grasp of the unity of a surface even extending to surfaces which though separated in space and apparently disconnected yet belong together both to the mathematicians and the sculptor." [1] Bernal, in a startling and brilliant juxtaposition of a scientific diagram and a work of modern sculpture, illustrates on a single page the equi-potential surface of two like charges and Hepworth's 1935 marble *Two Forms* (B.H. 68*). So uncannily similar are the two images—the space between the two like charges and indeed the proportions of the larger and smaller ovoids—as to suggest that the diagram could have been a preparatory drawing for the sculpture. Later in 1937, Bernal wrote the foreword to the catalogue of Hepworth's first solo exhibition at Alex. Reid and Lefevre Ltd., London. No one has bettered his description of the subtle, slightly irregular geometry that informs Hepworth's abstract carvings of the mid-1930s, which remained a consistent feature of her work—despite the reemergence in the early 1940s of strong figurative and landscape references.

By reducing traditional forms of sculpture it is possible to see the geometry which underlies it and which is so obscure in more elaborate work. In the hands of Miss Hepworth this geometry has taken on particularly subtle form. At first sight there has been a great loss of complexity when compared with her earlier work. The negative curvatures and the twists have all but disappeared and we are treated to a

*B.H. numbers refer to catalogue numbers from the two volume catalogue raisonné of Hepworth's sculpture.

series of surfaces of slightly varying positive curvature which enable the effects of small changes to be seen in a way that is impossible when the eye is distracted by grosser irregularities. The elements used are extremely simple: the sphere and the ellipsoid, the hollow cylinder and the hollow hemisphere. All the effects are gained either by slightly modulating these forms without breaking up their continuity, or by compositions combining two or three of them in different significant ways.[2]

• • •

The life and work of Barbara Hepworth, the first great female sculptor in the history of Western art, have been largely ignored or forgotten since her death in a fire at her home, Trewyn Studio, St. Ives, Cornwall, in 1975. The last important exhibition during her lifetime was organized by the Tate Gallery, London, in 1968. Coincidentally, in the past two years, three unrelated publications—one exhibition catalogue, one novel, and one biography—have done much to rekindle interest in Barbara Hepworth and to reevaluate her remarkable achievement. The catalogue, *Barbara Hepworth: A Retrospective*, published in 1994 to accompany the exhibition organized by the Tate Gallery, Liverpool, and the Art Gallery of Ontario, Toronto, includes scholarly essays by the co-curators, Penelope Curtis and Alan G. Wilkinson. Also published in 1994 was Robertson Davies' last novel, *The Cunning Man*, in which Hepworth appears as a friend and correspondent of

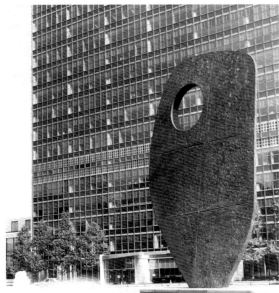

one of the main characters. The following year saw the publication of Sally Festing's unofficial biography, *Barbara Hepworth: A Life of Forms*. At present, the distinguished art historian Sir Alan Bowness, the artist's son-in-law, is working on the first volume of the *official* biography.

The Wildenstein exhibition marks the first time Hepworth's work has been shown in New York since 1979. How many New Yorkers are aware of the name of the woman who created one of the most successful public sculptures in Manhattan—the 21-foot-high bronze *Single Form* (1962-63) (fig. 1), commissioned as a memorial to Secretary-General Dag Hammarskjöld and unveiled in 1964 at the United Nations Headquarters? Perhaps the situation has improved somewhat since I drove past the sculpture in the late 1970s and mentioned to my daughter Anna that I had met the artist on one occasion. The taxi driver quipped knowingly: "She's Turkish ... it's the latest thing."

fig. 1: *Single Form*, 1962-63, bronze, 21′ high, United Nations Headquarters, New York

• • •

Yorkshire Background and the Formative London Years: 1903-1929

Yorkshire in the north of England, London in the southeast, and Cornwall in the southwest were the geographical and imaginative centers of Barbara Hepworth's life and work. She was born on January 10, 1903 in Wakefield in the West Riding of Yorkshire, the eldest of four children of Herbert R. Hepworth and Gertrude Allison (née Johnson). From modest beginnings her father, an engineer, reached the top of his profession, becoming Surveyor to the West Riding of Yorkshire. Barbara's childhood was a happy one, "a strange mixture of frugality and strong discipline...fused with an unusual sense of liberalism wherein a boy and girl were equal."[3] This must have given her enormous confidence in later years to associate, work, and exhibit on an equal footing with the most important painters and sculptors in the male-dominated world of the English avant-garde. It was her mother, Hepworth wrote in *A Pictorial Autobiography* (1970), "who saved and scraped to inspire me to further effort in music and dance and book scholarship."[4] Her father promised and was able to fulfill his dream of providing his three daughters and one son with equal educational opportunities.

From an early age, Hepworth's imagination was intoxicated by the landscape of her native Yorkshire, which was almost mystical in its intensity. She shared with Turner, Constable, Samuel Palmer, and Wordsworth a love of landscape that is often thought to define the quintessential "Englishness" of English art. The most lyrical and poetic of all her writings are descriptions of landscape—the landscape of Yorkshire, of Cornwall, and of Greece. On the one hand, she perceives the separateness of the powerful sculptural forms and shapes; on the other, she herself *becomes* the landscape. Her lifelong obsession with the human figure and the human spirit inhabiting the natural world began in early childhood:

> All my early memories are of forms and shapes and textures. Moving through and over the West Riding landscape with my father in his car, the hills were sculptures; the roads defined the form. Above all, there was the sensation of moving physically over the contours of fullnesses and concavities, through hollows and over peaks—feeling, touching, seeing, through mind and hand and eye. This sensation has never left me. I, the sculptor, am the landscape. I am the form and I am the hollow, the thrust and the contour.[5]

In 1909, Hepworth enrolled at Wakefield Girls' High School. Interestingly, it was the headmistress, Miss Gertrude McCroben, a mathematician by training, who inspired and encouraged the young student. At the age of seven, Hepworth was bewitched by the lantern slide images of Egyptian sculpture at one of Miss McCroben's art history lectures. It was the sudden revelation of a Joycean "epiphany," when the soul of an object seems radiant—the ecstasy of recognition, when one is suddenly transported and enthralled by an intense, mysterious identification with the language of Shakespeare, the music of Bach, or the sculpture of Brancusi.

Barbara began reading books on the history of sculpture. Her parents hoped that their eldest daughter would read English at Cambridge, but she had other plans. Barbara Hepworth wanted to become a sculptor. After graduating from high school, she was awarded, with the help of Miss McCroben, a scholarship to the Leeds School of Art, where she began her studies in the autumn of 1920.

Among Hepworth's friends and fellow students at Leeds was Henry Moore, four and a half years her senior. Born in nearby Castleford in 1898, the seventh child of a miner, Moore had also from an early age been determined to become a sculptor. (His shock of recognition occurred at Sunday school when he was told a story about Michelangelo. Like Hepworth, he had a mentor at high school, the art teacher, Miss Alice Gostick.) According to Moore, a sculpture department was introduced at Leeds at his request in 1919 when he began his two-year course; Hepworth, however, does not appear to have attended. In order to condense her two-year course into one, Hepworth concentrated on academic drawing: drawing from life, from the antique, and from memory. In 1921, she passed the drawing examination of the Board of Education and was granted a Senior Art Scholarship. In the autumn of that year, Hepworth and Moore arrived in London to study sculpture at the Royal College of Art. For the next two decades, the names, work and lives of the two Yorkshire-born sculptors were, in the development of modernism in British sculpture, as closely linked as those of Braque and Picasso in the creation of Cubism from 1907 to 1914.

At the Royal College of Art from 1921 to 1923, Hepworth was exposed to the traditional, academic training based on life drawing and modeling in clay from the nude figure. Direct carving in stone, which by the mid-1920s became an all consuming passion for Hepworth, was not seen as an end in itself, but rather as a mechanical way of translating clay or plaster studies into larger stone sculptures with the use of a pointing machine. Exactly when Hepworth made her first carvings is unclear. That none of her sculpture has survived from her years at the Royal College of Art seems strange. It is generally assumed that like Moore, whose carvings from the early 1920s have survived, she found time to carve during the holidays. The 1925 marble *Doves* (B.H. 1, destroyed) is, however, her earliest recorded carving.

Sir William Rothenstein, the Principal of the Royal College of Art, invited his students to his home, where they met well-known politicians, poets, and novelists. The most influential teacher at the College was the sculptor Leon Underwood, who served as the drawing master. Both Hepworth and Moore attended his private evening classes in life drawing and absorbed his interest in African tribal sculpture and his commitment to direct carving. On at least one occasion in the early 1920s, Barbara visited Paris with Moore and their close friends from student days in Leeds, Raymond Coxon and Edna Ginesi. One can only speculate as to what Barbara saw and responded to in Parisian museums and commercial galleries. In London, inspired by Henry Moore's interests, she must have visited the British Museum a number of times, but we have no record of which specific works of sculpture appealed to her. Whereas Moore, through his writings and early sketchbooks, has left a fascinating and detailed account of his activities and of the sculptures he most admired during his student years in London—Assyrian, Egyptian, Cycladic, African, and

Oceanic, and above all, pre-Columbian art (dozens of drawings of particular works have been identified)— Hepworth left only a brief account of her life during those crucial formative years in London. I suspect that Hepworth was no more inclined to make sketches in a notebook of works of art in the British Museum than to make preparatory drawings for her sculpture. For all the stylistic affinities between Hepworth's and Moore's carvings in the 1920s and '30s, the creative process and the workings of their imaginations could not have been more different. Moore relied entirely on drawing as an intermediate step to generate ideas for sculpture. He *needed* an image on a page from which to work, and often drew ten or fifteen variations on a given theme on a single sheet. Hepworth's approach was entirely conceptual and direct. To Alan Bowness' question, "You

fig. 2: With John Skeaping at the British School in Rome, 1925

don't sometimes start with a rough idea of what you want and let the work lead you through?" she replied, "No, I don't. I have to fall in with the material I'm using, but I always know what I want from the beginning."[6]

In September 1924, a year after graduating from the Royal College of Art, Barbara Hepworth left for Italy, having been awarded a scholarship to study abroad. She studied Romanesque and early Renaissance sculpture and the work of Giotto, Cimabue, Masaccio, and Michelangelo. In Rome, Barbara met the sculptor John Skeaping, who had won the Prix de Rome, a competition for which she had been the runner-up. They were married in Florence on May 13, 1925 and moved to Rome, where they lived and worked at the British School (fig. 2).

During the two years she spent in Italy (September 1924 - October 1926), two inseparable experiences made a lasting impression on Hepworth. One was the discovery of the intensity of the Mediterranean light; the other was her introduction to the technique of stone carving through her husband. She perceived the effects of light from a sculptor's point of view—that is, how light mutates form and color:

> Italy opened for me the wonderful realm of light—light which transforms and reveals, which intensifies the subtleties of form and contours and colour, and in which darkness the darkness of window, door, or arch—is set as an altogether new and tangible object. To my northern conception it added a knowledge of the grace of the Mediterranean approach which imparts a richness and gaiety into the "living" material of marble and stone.[7]

During her first year in Italy, she made no sculpture. It was clearly Skeaping's example—he was an accomplished carver when they met, having apprenticed with Giovanni Ardini, a master carver—

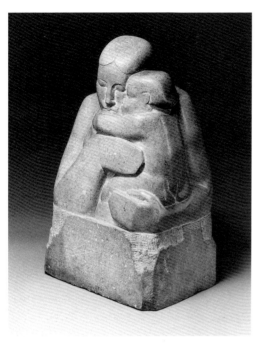

fig. 3: Barbara Hepworth, *Mother and Child*, 1927
Hopton wood stone, 17¾ x 26 x 8¼", Art Gallery of Ontario

that gave Hepworth the confidence and the technical skills to proceed. (One can only speculate as to why Henry Moore, whom the younger Hepworth obviously worshipped, did not take her under his wing during their years together at the Royal College of Art, and teach her the rudiments of stone carving). A chance remark by Ardini that "marble changes colour under different people's hands" made Hepworth aware "that it was not dominance which one had to attain over material, but an understanding, almost a kind of persuasion, and above all greater co-ordination between head and hand."[8] In October 1926, Hepworth and Skeaping returned to London "with a few carvings and my favourite birds from my aviary; but we had to leave behind some wonderful blocks of marble."[9]

They settled first in Primrose Hill, and in April 1927 rented a basement flat in St. Ann's Terrace, St. John's Wood. By December of that year, the two sculptors had produced enough work to warrant a modest exhibition at their St. John's Wood studio. There were no visitors, Hepworth recalled many years later, until the fourteenth day, when Richard Bedford, himself a sculptor and Head of the Department of Sculpture at the Victoria and Albert Museum, brought George Eumorfopoulos to the studio. The Greek millionaire and distinguished collector of Chinese porcelain bought carvings from each of them, including three by Hepworth: *Doves* (1927; B.H. 3), Manchester City Art Galleries; *Seated Figure* (1927; B.H. 5); and *Mother and Child*, 1927 (fig. 3), Art Gallery of Ontario, Toronto. To have this notable collector of Chinese art arrive unexpectedly at their studio and acquire three of the eight or so carvings she had produced to date must have left Hepworth wondering "do I wake or sleep?" Other collectors of Hepworth's early work included the banker George Seligman and George Hill, then of the Department of Coins and Medals and later the Director of the British Museum.

Hepworth's earliest surviving carvings date from 1927, when her work was still firmly rooted in the figurative tradition. Indeed, a number of sculptures of the late 1920s are closely related to the life drawings of the period, although the forms of her carvings are more massive and simplified. In the 1927 Hopton wood stone *Mother and Child* which is strongly reminiscent of and may well have been influenced by Moore's 1925-26 *Mother and Child* (Manchester City Art Galleries), the two figures, while fully realized in the round, are shown in high relief, thus retaining much of the monolithic shape of the original block. Hepworth was still struggling to come to terms with the material and was hesitant—or lacked the confidence—to free certain features, such as the necks and arms, from the massive block of stone. Moore's description of his carvings of the mid-1920s, and the technical reason why the form of the original block of stone dominates, apply equally well to Hepworth's 1927 *Mother and Child*. The forms, he wrote, "were

all buried inside each other and heads were given no necks. As a result, you will find that in some of my early work, there is no neck simply because I was frightened to weaken the stone."[10] Despite the obvious formal stylistic similarities between Hepworth's and Moore's two maternity carvings, there is a fundamental difference in mood, in what might be called the "personality" of each work. Hepworth's *Mother and Child* radiates a sense of calmness and serenity, while Moore's version of the subject is alert and tense, with a pent-up energy and a somewhat disturbing aggressiveness. Barbara's work reflects her interest in the still, timeless beauty of Egyptian and Archaic Greek sculpture; Henry's work echoes his interest in the vitality and demonic power of African tribal art and in pre-Columbian sculpture.

In the 1920s Hepworth did, however, share Moore's enthusiasm for the early carvings of Epstein and for the work of Gaudier-Brzeska, the two most important avant-garde sculptors in the early history of British modernism, whose most influential work was created in London between 1910 and 1914. (Gaudier-Brzeska was killed in action in 1914). It is tempting to speculate that Hepworth's 1927 marble *Doves* was directly inspired by Epstein's carving *Doves* of c. 1913 (Tate Gallery). She would almost certainly have read Ezra Pound's illustrated *Gaudier-Brzeska: A Memoir* (1916). Her small *animalier* sculptures of 1927-30—*Toad, Goose, Dog, Marten, Dying Bird,* and *Fish* (only the green onyx *Toad* has survived)—have much in common, both stylistically and in the choice of exotic stones, with the animal sculptures of Skeaping. Hepworth was almost certainly inspired as well by Gaudier-Brzeska's intimate, small-scale sculptures on similar themes, and quite possibly by Chinese jades of animal, bird, and fish motifs, dating from the late Neolithic period (4,000 - 2,500 B.C.) and from the Warring States period (475 - 221 B.C.).[11]

Early in 1928, Hepworth and Skeaping had moved to 7 The Mall Studios, Parkhill Road, Hampstead (fig. 4). In June of that year, they held their first joint, public exhibition at the Beaux Arts Gallery, London, and also contributed carvings to *Modern and African Sculpture* at the Sydney Burney Gallery, which included works by Bedford, Dobson, and Epstein, juxtaposed with tribal sculpture. Their Beaux Arts exhibition was extensively reviewed in the national press, almost all of the reviews favorable. In the late 1920s, Hepworth and Skeaping were, with Moore, clearly perceived as two of the most important artists of the younger generation of British sculptors. Within a year of her first exhibition in the St. John's Wood studio, Hepworth had the support and admiration of colleagues, collectors, critics and dealers.

By 1929, the Hepworth/Skeaping marriage was beginning to falter, and the birth of their son, Paul, in August, did little to improve the situation. (They were divorced in 1933.) Hepworth's work, however, just two

fig. 4: 7 The Mall Studios, Hampstead, c. 1933

years after completing the monolithic *Mother and Child*, had progressed considerably in its confidence and ability to free the forms of the human figure from the stone block, to carve through the material, to open out the spaces between the arms and the torso, as in the 1929-30 stone *Figure of a Woman* (Tate Gallery, B.H. 27). In this year, no doubt under the supervision of Skeaping, she made her first wood carvings. Even at this early stage in her career, Hepworth's sculpture reflects not only her total commitment to direct carving, but her love of working in an extraordinary range of stone and wood, both indigenous and exotic: English Hopton wood stone and English Hornton stone; Carrara marble; Irish fossil marble; Cornish serpentine; alabaster; Norwegian soapstone; ebony; Burmese wood; African ivory wood; teak. "At this time," she wrote of the years 1928-29, "all the carvings were an effort to find a personal accord with the stones or wood which I was carving. I was fascinated by the new problem which arose out of each sculpture, and by the kind of form that grew out of achieving a personal harmony with the material." [12]

The year 1929 also saw the renewal of Barbara's close friendship with Moore, which had far-reaching consequences for the history of the modernist movement in England during the next decade. Barbara was responsible for finding a studio flat for Henry and his wife, Irina, at 11A Parkhill Road, very close to her digs at 7 The Mall Studios. During the 1930s, Hepworth and Moore would be joined in Hampstead by other leading artists, critics, architects, and writers, who formed what Herbert Read affectionately called "a 'nest' of gentle artists...." [13] Not only was Hepworth responsible for establishing the nest, she would continue to help fill it.

• • •

The 1930s: "Constructive Forms and Poetic Structure"

> Decades, like centuries, are arbitrary divisions of the flow of time, but now that we can look back on the years 1930-40 we can have no doubt that they were decisive in the history of art in England. [14]

"By 1930," Hepworth wrote, "I felt sure I could respond to all the varieties of wood growth or stone structure and texture. The *Head* {B.H. 32] carved in 1930 expressed that feeling of freedom, and a new period began in which my idea formed independently of the block. I wanted to break down the accepted order and rebuild and make my own order." [15] For Hepworth, as for Moore, the decade of the 1920s had been a period of struggle with the technical problems of carving, of learning how to release fully three-dimensional shapes from the solidity of stone or wood, as opposed to the definition of forms by surface cutting in relief. Hepworth herself later characterized the 1920s simply as "the excitement of discovering the nature of carving." [16] The next two periods, which completed her London years, she summed up as: "the breaking up of the accepted structural order, and the poetry of the figure in landscape 1931-1934," and "constructive forms and poetic structure 1934-1939." [17]

In October 1930, Hepworth and Skeaping held their second, joint, public exhibition, this time at Arthur Tooth and Sons Gallery, New Bond Street, London. This was to be their last show together. In April 1931, Barbara shared an exhibition (in fact she showed only one sculpture) with the painter Ben Nicholson and the potter William Staite Murray at the Bloomsbury Gallery, London. It was probably at this exhibition that she met Nicholson for the first time. She has described the exhilaration of seeing the work of a painter with aims parallel to her own, and of the way in which his landscapes and still lifes profoundly altered her vision of form, color, and perspective:

> To find an equivalent movement in painting to the one of which I was a part in sculpture was very exciting, and the impact of Ben Nicholson's work had a deep effect on me, opening up a new and imaginative approach to the object in land-scape, or group in space, and a free conception of colour and form. It often happens that one can obtain special revelations through a similar idea in a different medium. The first exhibition which I saw of his work revealed a freedom of approach to colour and perspective which was new to me. The experience helped to release my energies for an exploration of free sculptural form....[18]

Ben Nicholson, nine years older than Hepworth, was recognized as one of the leading figures of the English avant-garde. The son of William Nicholson, himself a distinguished painter, Ben had, by 1930, begun to establish contacts in Paris with artists, collectors, and dealers. Since 1928, Nicholson and Hepworth had been exhibiting separately at the same two London dealers—Beaux Arts Gallery and Arthur Tooth and Sons. If she had seen his work there, or at other exhibitions at the Lefevre Gallery and Leicester Galleries, she does not appear to have responded to it immediately.

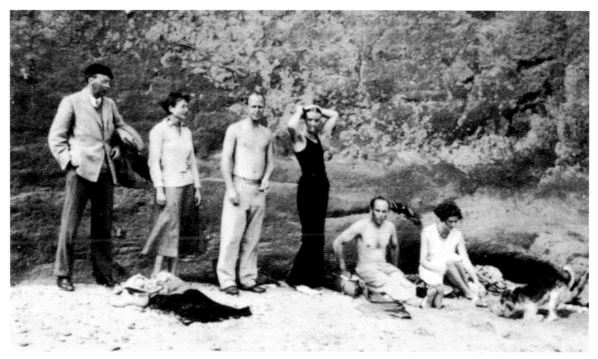

fig. 5: Ivon Hitchens, Irina Moore, Henry Moore, Barbara Hepworth, Ben Nicholson, and Mary Jenkins, Happisburgh, 1931. Photo: Douglas Jenkins

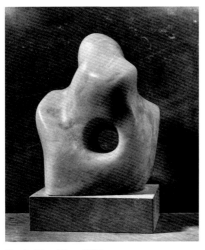

fig. 6: *Pierced Form*, 1931
pink alabaster, 10″ high (destroyed)

In April 1931, Nicholson and his wife, Winifred, spent an evening with Hepworth and Skeaping at 7 The Mall Studios in Hampstead. Barbara's interest in Ben's work was such that she arranged to borrow several of his paintings. That summer, Hepworth was planning to spend her second consecutive holiday on the Norfolk coast, where she had rented Church Farm at Happisburgh. Again, she was joined by Henry and Irina Moore and the painter Ivon Hitchens. This year, the Nicholsons were also invited (fig. 5). Ben arrived on his own, leaving his wife and three children at their farmhouse in Cumberland. The Nicholsons had been experiencing difficulties in their marriage since the mid-1920s. By September 26, when Ben left Happisburgh to return home, he had spent a fortnight with Hepworth and her friends. Both Henry and Irina Moore and John Skeaping had departed before Nicholson, leaving Ben and Barbara on their own. At whatever level the friendship between Nicholson and Hepworth had begun, by the end of the holiday in Norfolk one assumes the relationship had reached a greater level of intimacy.

Hepworth's 1931 alabaster *Pierced Form* (fig. 6) (also known as *Abstraction*, B.H. 35) might well be described as her "first sculpture," in the sense that Barnett Newman called *Onement 1* (1948), with its vertical zip, his "first painting."[19] Hepworth carved through the center of the sculpture, thereby creating for the first time in her work an abstract hole that has no reference to the logic of human anatomy. The title itself refers to the physical act of cutting into and through the form. Hepworth had inaugurated what was to become for her and Moore one of the most important formal features of their work. Of the carving she wrote:

> ...in the *Pierced Form*, I had felt the most intense pleasure in piercing the stone in order to make an abstract form and space; quite a different sensation from that of doing it for the purpose of realism.[20]

Hepworth has recorded how impressed Moore was when he saw *Pierced Form* in her studio.[21] Since the abstract hole does not appear in Moore's work until 1933, Hepworth should be credited with having initiated this formal "breakthrough." But in the last analysis, who got there first is of little consequence. In fact, in the history of modern sculpture, "negative space"—that rather silly, trendy term used to describe what the artists surely have perceived as very *positive* interior space surrounded by solid form—predates the work of Hepworth and Moore by nearly two decades. By 1912, the abstract hole was a dominant feature in the sculpture of Archipenko, and had also appeared in Gaudier-Brzeska's 1914 cut brass *Ornament Torpille* (Art Gallery of Ontario), one of his last works. Solids and voids are equally balanced in Lipchitz' small bronze "transparents" of the mid-1920s. From the late 1920s to the mid-1930s, Hepworth and Moore enjoyed a symbiotic creative partnership so intimate, with their carvings stylistically so closely related that, as with

the Cubist paintings of Braque and Picasso from the summer of 1911, it takes a highly experienced and intuitive eye to be able to identify the authorship of much of the work produced.

In the autumn of 1931, following the summer holiday on the Norfolk coast (fig. 7), the relationship between Hepworth and Nicholson continued to blossom. By November, he had moved from Chelsea to rented rooms at 53 Parkhill Road. Nicholson's reasons for moving to Hampstead were twofold: the potential of his romance with Barbara,

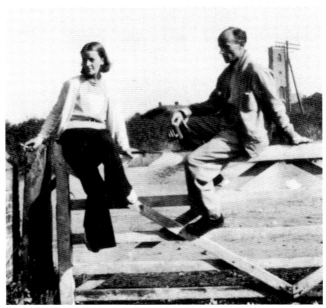

fig. 7: With Ben Nicholson at Happisburgh, Norfolk, 1931

and his friendship and interest in the work and ideas of Henry Moore. With Barbara, Ben, and Henry living and working within a "pebble's" throw from each other, Hampstead was now the geographical center of the English avant-garde. As Herbert Read has written, "...Henry Moore, Ben Nicholson, Barbara Hepworth and several other artists were living and working together in Hampstead, as closely and intimately as the artists of Florence and Siena had lived and worked in the Quattrocento."[22] By the end of the decade, Hampstead's "nest of gentle artists" included Paul Nash, Roland Penrose, Piet Mondrian, Naum Gabo, Marcel Breuer, Walter Gropius, Herbert Read, Adrian Stokes, and Geoffrey Grigson. It was not only the artists who played an influential role in Hepworth's life. The critics Read, Stokes, and Grigson provided much needed moral support with their perceptive and sympathetic reviews of her sculpture.

By March 1932, Hepworth and Nicholson were sharing 7 The Mall Studios, although Ben continued to rent rooms at 53 Parkhill Road. The work of both artists was enriched by the cross-fertilization of ideas and forms from sculpture to painting and from painting to sculpture. That Hepworth and her carvings are depicted in a number of Nicholson's paintings and drawings of 1932-33 attests to his love for his beautiful model and his intense interest in her work.

In November 1932, Hepworth and Nicholson held a joint exhibition at Arthur Tooth and Sons Galleries. The show was an event of great significance on several counts. It publicly announced her break with Skeaping and her new alliance to Nicholson. Herbert Read wrote a short foreword to her sculptures in the catalogue. Not only was Hepworth exhibiting as an equal partner with the most important English painter of his generation, but she had the support of the most influential critic of the modernist movement in England. His comment "That some of Miss Hepworth's creative conceptions...recede into a symbolic world of abstractions"[23] may have been the first time her work was described as abstract. In his review of the same exhibition in *The Week-end Review*, the painter Paul Nash remarked on "a delightful unity" achieved by the

juxtaposition of the works of "A Painter and a Sculptor," the title of his article. He ended his comments with a statement that sums up the essential character of Hepworth's work of 1931-32, which was indeed moving in the direction of total abstraction:

> Each object is purely sculptural—the embodiment of an idea neither literary, naturalistic, nor philosophical, but simply formal: its meaning is itself, itself the only meaning. [24]

When Hepworth joined Nicholson in Paris on April 2, 1933, he had already met Picasso, Braque, Zadkine, Man Ray, and possibly Giacometti. The couple spent the Easter holidays at Avignon and St. Rémy de Provence. On their return to Paris, they were invited to join *Abstraction-Création*, the Parisian society of painters and sculptors. Before returning to London, they visited Picasso, and the studios of Arp and Brancusi, two sculptors whose work, in very different ways, profoundly altered Hepworth's formal vocabulary. Although she disliked the dead white plaster with which Arp's first three-dimensional sculptures were made, she responded to their organic poetry, to the way in which he had fused landscape with the human form: "I began to imagine the earth rising and becoming human. I speculated as to how I was to find my own identification, as a human being and a sculptor, with the landscape around me." [25] Hepworth's visit to Brancusi's studio produced a very different response. Brancusi's sculptures epitomized what she herself was striving for—the harmony between form and material.

> In Brancusi's studio, I encountered the miraculous feeling of eternity mixed with beloved stone and stone dust.... The quiet, earthburned shapes of human heads or elliptical fish, soaring forms of birds, or the great eternal column in wood, emphasized this complete unity of form and material. [26]

Two carvings of 1933, *Two Forms* (B.H. 51) and *Figure (Mother and Child)* (B.H. 52), which marked a new departure for Hepworth, must have been made soon after she returned to London. They are the first in the series of multipart compositions which became not only one of the most important motifs in her subsequent sculpture of the 1930s, but a lifelong obsession. Undoubtedly, Hepworth's two-piece carvings of 1933-34 were directly inspired by Arp's early three-dimensional work, such as his 1931 painted wood *Necktie and Navel*, and his multipart sculptures in which one or more small forms rest or balance on a single larger form. Adrian Stokes, in his review in *The Spectator* (November 3, 1933) of Hepworth's October 1933 exhibition with Nicholson at Alex. Reid and Lefevre Ltd., described in terms still unequaled the unique qualities of stone and the sculptor's special bond with her material: "A glance at the carvings shows that their unstressed rounded shapes magnify the equality of radiance so typical of stone...." Of *Figure (Mother and Child)* he wrote: "It is not a matter of a mother and child group represented in stone. Miss Hepworth's stone is a mother, her huge pebble its child." [27]

In early December 1933, on a visit to Paris, Nicholson took what in retrospect seems like an inevitable step when he made his first carved relief. Although in his earlier work he had been very

physically involved with rubbing, scraping, and scratching incised lines into the surface of the boards on which he painted, his interest in actual carving was stimulated by his intimate working relationship with Hepworth. In a letter postmarked December 8, she wrote to him in Paris: "I am very interested in your new work idea (carving out) *naturally*—I've been longing for it to happen for ages." [28] Ben returned to London on December 31 and for the next two months concentrated on his carved and painted reliefs, joining Hepworth and Moore in practicing the art of sculpture.

In the early months of 1934, Hepworth learned that she was expecting a baby in the autumn. It is not surprising that the mother and child theme was the subject of the first four carvings of that year. In April 1934, Hepworth exhibited in the *Unit One* exhibition at the Mayor Gallery, London, and contributed a short essay to the publication *Unit One: The Modern Movement in English Architecture, Painting and Sculpture*, edited by Herbert Read. Her statement reads like a manifesto announcing the dawn of a new era: "There is freedom," she wrote, "to work out ideas and today seems alive with a sense of imminent new discovery." [29] A new era in her life was indeed about to begin.

"On October 3rd, 1934," Hepworth recounted, "our triplets were born, Simon, Rachel, and Sarah, in a small basement flat very near our studio. It was a tremendously exciting event. We were only prepared for one child and the arrival of three babies by six o'clock in the morning meant considerable improvisation for the next few days." [30] Some four hours before the babies were born, Nicholson completed a carved relief entitled *October 2, 1934 (white relief-triplets)*, in which the two circles and one rectangle parallel the ratio of two girls and one boy. Of this relief carving he wrote to a friend, probably in the late 1940s: "I hope you recognize the forecast of Simon, Rachel and Sarah? and that after H.G. Wells said that only writers are prophetic." [31]

Of her return to sculpture, Hepworth wrote: "When I started carving again in November 1934 [it may in fact not have been until December or early in the new year], my work seemed to have changed direction although the only fresh influence had been the arrival of the children. The work was more formal and all traces of naturalism had disappeared, and for some years I was absorbed in the relationships in space, in size and texture and weight, as well as in the tensions between the forms." [32] In her first abstract carvings, all traces of identifiable figurative "signs," such as an incised eye, nose, or hand have disappeared. The titles, one of which uses the language of geometry for the first time, are as abstract as the works themselves: *Two Forms*; *Two Forms with Sphere*; *Three Forms*. Whatever the associations may have been for Hepworth, it is difficult for me not to associate the Tate Gallery's serenely beautiful 1935 marble *Three Forms* (fig. 8) with the arrival of the triplets. Despite the uncompromising abstraction of her carvings of the mid-1930s, the forms were, as Ronald Alley has pointed out, "seldom geometrically absolutely regular (like the circles and rectangles used by Ben Nicholson

fig. 8: *Three Forms*, 1935, white marble, 20″ long
Tate Gallery, London, gift of J.R.M. Brumwell

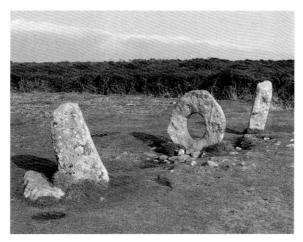

fig. 9: Mên-an-tol (stone of the hole), near Morvah, Cornwall
Photo: Alan G. Wilkinson, courtesy Art Gallery of Ontario

at the same period) but...derived much of their appeal from slight deviations from regularity which gave them an organic character." [33] Hepworth managed, with an extraordinary degree of subtlety, to infuse her abstract work with a delicacy and purity that somehow avoids any hint of excessive refinement or the merely decorative. Her supreme and rarely acknowledged achievement in creating these carvings of the mid-1930s is that they represent the first consistent group of abstract sculpture in the history of twentieth-century art.

Both in Hepworth's life and work, the mid-1930s reflect the growing influence of the Parisian avant-garde. She met Mondrian on a trip to Paris with Ben in late December 1934. In the spring or early summer of 1935, she met the Russian Constructivist sculptor Naum Gabo. Both the work of Arp and even more so the Surrealist sculptures of Giacometti had a considerable impact on her carvings of 1935-36. For all her allegiance to geometric abstraction, Hepworth made several carvings at the time, such as the 1935-36 *Two Segments and Sphere* (B.H. 79)—which must surely have been inspired by Giacometti's 1930 *Suspended Ball*—that could well have been included, as was Moore's work, in the 1936 *International Surrealist Exhibition* in London. She did, however, take part in the 1936 exhibition *Abstract and Concrete* in Oxford, which included works by Arp, Calder, Gabo, Giacometti, Kandinsky, Mondrian, and Nicholson.

In July 1937, *Circle: International Survey of Constructive Art* was published to coincide with the Constructive Art exhibition at the London Gallery. Gabo, Hepworth, and Moore were the three artists who contributed essays to the section on sculpture. In October, Hepworth had her first solo exhibition at Alex. Reid and Lefevre Ltd. A passage from J.D. Bernal's catalogue foreword was quoted at the beginning of this essay. Prophetically, in discussing one group of carvings—the soaring, vertical forms, which had now become and were to remain one of the major themes in her work—Bernal sees them as corresponding to the Neolithic menhirs of Cornwall and Brittany that were to affect Hepworth so deeply after she moved to Cornwall in 1939. In discussing another series—"stones pierced in one way or another with conical holes" [34]—he compares them to Mên-an-tol (stone of the hole), one of Cornwall's best-known prehistoric monuments (fig. 9).

Of the five sculptures Hepworth produced in 1939, two were intended for outdoor settings. In the titles themselves—*Project for Sculpture in a Landscape* (B.H. 115) and *Project for Garden Sculpture* (B.H. 116)—she announces for the first time what was soon to become one of the most important themes in her work: the relationship of the human figure and of sculpture in landscape. Also significant is the fact that these plaster maquettes were the first small-scale preparatory studies for larger works. The enchanting plaster *Sculpture with Colour, White, Blue and Red Strings* (B.H. 113) was one of the most innovative and prophetic of the 1939 sculptures. With the introduction of color and string, Hepworth combined in a single work two elements which were

to play a major role in her subsequent sculpture. Her use of color is clearly related to Nicholson's paintings and carved white reliefs. They shared one of the great romantic and artistic partnerships in the history of twentieth-century art. As she later wrote: "Our influence on each other remained free and stimulating and is shown, I think, at its best in the coloured reliefs of Ben Nicholson's and in my sculptures with colour which were to come later." [35] Ben and Barbara were married at the Hampstead Registry Office on November 17, 1938.

Toward the end of August 1939, Ben and Barbara and their three children were invited to stay with Adrian Stokes and his wife, Margaret Mellis, in Carbis Bay, near St. Ives, Cornwall. "The last person we saw in August was Mondrian," Hepworth wrote, "and we begged him to come with us in our battered old car (which we bought for £17) so that we could look after him. But he would not." [36] The departure of Hepworth and Nicholson for Cornwall brought to a close their London years and marked the beginning of the end of Hampstead's "nest of gentle artists," which they, through their friendships at home and abroad, had done so much to build. Two weeks later, Naum and Miriam Gabo joined them in Carbis Bay. In October 1940, Henry and Irina Moore left Hampstead after their studio was damaged in an air raid and moved to Much Hadham in rural Hertfordshire. That same month, Mondrian emigrated to New York. "At the most difficult moment of this period," Hepworth recalled, "I did the maquette for the first sculpture with colour, and when I took the children to Cornwall five days before war was declared I took the maquette with me, also my hammer and a minimum of stone-carving tools." [37]

• • •

Cornwall 1939-1975

> I cannot write anything about landscape without writing about the human figure and the human spirit inhabiting the landscape. For me, the whole art of sculpture is the fusion of these two elements—the balance of sensation and evocation of man in this universe. [38]

On August 25, 1939, Barbara Hepworth, Ben Nicholson, and the triplets, together with a nanny and a cook, arrived at Little Park Owles, the home of Adrian Stokes and Margaret Mellis. Ben was already familiar with this part of Cornwall, having spent two and a half months in the area in 1928 with his first wife, Winifred, and the painter Christopher Wood. St. Ives, on the north coast of the narrow Penwith peninsula, had for many years been an artist's colony (fig. 10).

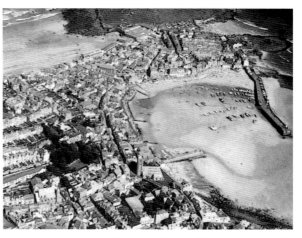

fig. 10: Aerial view of St. Ives, Cornwall, 1967

(Carbis Bay is a suburb of the small town of St. Ives; the names are often used interchangeably). J.M.W. Turner visited the town in 1811 on a sketching tour of Devon and Cornwall. Whistler and Sickert spent part of the winter of 1883-84 in St. Ives painting in oil and watercolor. Hepworth recalled her state of mind when she arrived:

> Ben knew St. Ives; but in spite of what Prof. J.D. Bernal wrote (prophetically) in 1937, I felt opposed to coming to a place I had never seen. Arriving in August at midnight with very weary children, in pouring rain, my spirits were at zero. Next morning I appreciated the beauty and sense of community, and realized that it would be possible to find some manual work and raise the children, and take part in community life, which has nourished me ever since.[39]

When war was declared on September 3, Stokes invited Hepworth and her family to stay on with them for the safety of the children. In mid-September, Naum and Miriam Gabo arrived in Carbis Bay and moved into a bungalow a few minutes walk from Little Park Owles. Of the three artists now living in the relocated "nest" 250 miles southwest of London, only Gabo remained consistently faithful to constructive ideals. Neither Hepworth nor Nicholson could ignore the landscape of Cornwall which was to change the course of their art in the 1940s as profoundly as the theories of geometric abstraction and the work of the Parisian avant-garde had altered the direction of their sculpture and painting in the 1930s.

Cornwall is a windy place and nowhere far from the sea. It includes England's most southerly as well as its most westerly point, yet there is nothing soft in its landscape or its people. With its spectacular cliffs and coves, headlands, and sea-worn caves, its rock formations rising out of the sea, its massive boulders deposited on hill tops, Cornwall is as sculptural a landscape as exists in England. The horizon is dominated by the silhouettes of the ruins of abandoned tin mines whose tall chimneys seem to echo, as do the prehistoric standing stones, the vertical forms of Hepworth's sculpture and ultimately her obsession with the human figure inhabiting the landscape.

At the end of December 1939, Hepworth and her family moved to Dunluce, a small house in Carbis Bay, without adequate space for a sculpture studio. During the first three years of the war she did very little sculpture, apart from a series of small plaster maquettes with color and string which were a continuation of the first small painted sculpture with strings, executed in 1939, and brought from London to Cornwall. Not only was there a shortage of artists' materials throughout the war, but Barbara's life was largely taken up with domestic chores. Drawing proved to be an important outlet for her creative energies during the early 1940s. Her abstract drawings of 1940-42, which owe a considerable debt to the work of Gabo, are among the most beautiful and austere of her exploratory studies of sculptural ideas.

In July 1942, Hepworth and Nicholson signed a seven-year lease on a larger house, Chy-an-Kerris, Carbis Bay.

> A new era seemed to begin for me when we moved into a larger house high on the cliff overlooking the grand sweep of the whole of St. Ives Bay from the Island

to Godrevy lighthouse....I had a studio workroom looking straight towards the horizon of the sea and enfolded (but with always the escape for the eye straight out to the Atlantic) by the arms of land to the left and right of me. I have used this idea in *Pelagos*, 1946. [40]

By 1943, Hepworth had found the time, the space, and the materials to begin carving again. She had also begun to explore the dramatic landscape of the Penwith peninsula. Her description of the barren terrain of west Cornwall and its impact on her work provides the best introduction to her sculpture of the 1940s:

> It was during this time that I gradually discovered the remarkable pagan landscape which lies between St. Ives, Penzance and Land's End; a landscape which still has a very deep effect on me, developing all my ideas about the relationship of the human figure in landscape—sculpture in landscape and the essential quality of light in relation to sculpture which induced a new way of piercing the forms to contain colour. [41]

Although her sculpture constantly changed and evolved from her first mature carvings of the early 1930s to her last works of 1974-75, Hepworth chose to explore variations on three major themes or formal structures. As in the sculpture of Brancusi, her entire oeuvre, with its extraordinary stylistic unity, seems totally focused and self-contained. She wrote in *A Pictorial Autobiography*:

> The forms which have had special meaning for me since childhood have been the standing form (which is the translation of my feeling towards the human being standing in landscape); the two forms (which is the tender relationship of one living thing beside another); and the closed form, such as the oval, spherical or pierced form (sometimes incorporating colour) which translates for me the association and meaning of gesture in landscape.... [42]

Whereas Moore described the two main themes of his work—the mother and child and the reclining figure—in simple terms of human subject matter, Hepworth begins with purely formal and structural descriptions—standing form, two forms, and pierced form—and then leads us into the human associations which these shapes and relationships have for her. When she began carving again in 1943, the abstract geometry of her work from the mid- to late 1930s—the cones, hemispheres and polyhedrons—was replaced by semi-abstract subjects with strong figurative or landscape associations.

Oval Sculpture (1943; B.H. 121) and *Wave* (1943-44; B.H. 122), the first wood carvings to include color and strings, were also the first sculptures inspired by the landscape and seascape of Cornwall. The blue interior of *Wave* corresponds to the color of the ocean; the deeply gouged out, interior space (it can no longer be described as a mere hole) of *Oval Sculpture* echoes the shapes of caves. The color, concavities, and strings represented for Hepworth abstract equivalents of bodily sensations in landscape:

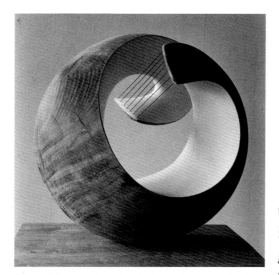

fig. 11: *Pelagos*, 1946, wood with colour and strings, 16" high
Tate Gallery, London

I used colour and strings in many of the carvings of this time. The colour in the concavities plunged me into the depth of water, caves, or shadows deeper than the carved concavities themselves. The strings were the tension I felt between myself and the sea, the wind or the hills.[43]

Pelagos "the sea" of 1946 (fig. 11), a pendant to the *Wave*, is one of Hepworth's very few landscape-inspired sculptures to relate in a detailed way to a geographical location in Cornwall—the view from her house in Carbis Bay overlooking St. Ives Bay toward Godrevy lighthouse, with the Atlantic Ocean enfolded by the arms of land to the left and right. This was the prospect that inspired Virginia Woolf's *To the Lighthouse* (although the novel is set in the Hebrides), which she described in her journal of 1905, using a phrase remarkably similar to Hepworth's "grand sweep of the whole of St. Ives Bay": "From the raised platform of the high road we beheld the curve which seemed to enclose a great sweep of bay full tonight of liquid mist, set with silver stars...."[44]

Pelagos is one of the supreme achievements of Hepworth's entire career. On the one hand, the daring, technical brilliance in managing to open out the wood to this extent—pushing the physical limits of the medium to the maximum—almost defies credibility and the notion of truth to materials. On the other, the movement, texture, color, and tension of *Pelagos* represent, on a semi-abstract level, a most beautifully resolved form, with lyrical and poetic associations with the landscape that inspired it.

In 1947, Hepworth began to use Cornish place names in the titles of some of her sculptures, the names of towns, hills, beaches, cliffs, coves, islands, and prehistoric menhirs and quoits. In a conversation with Alan Bowness, she explained the often distant, subconscious links between the completed sculptures and the titles they were assigned. "They are always added later. When I've made something, I think: 'Where did I get that idea from?...' But I don't start with a title: I make a shape, and there may or may not be an association with it—but this comes afterwards."[45]

During the 1940s, it was not only landscape sculptures that announced Hepworth's "return to nature." The human figure also emerged as an equally important theme, in carvings such as the 1945-46 Cornish elm *Single Form (Dryad)* (p. 35). The humanoid shape is clearly recognizable with the bulblike head, elongated neck, and tapering shoulders. The reference in the title to a mythological dryad (a nymph who lived among the trees) would have been added later, as Hepworth explained. She also continued to create abstract sculptures that are closely related to her carvings of the mid- to late 1930s, particularly to the twisting, spiraling forms found in the 1938 *Heloids in Sphere* (B.H. 109). But the geometry of the curvilinear forms of the abstract carvings of the mid- to late 1940s is more organic and lyrical than in the earlier work.

Even during the war years, Hepworth continued to exhibit regularly, as she had done in the 1930s. Her first museum exhibitions were, appropriately, held in Yorkshire. In 1943, she showed with Paul Nash at Temple Newsam, Leeds, and in the following year, had an exhibition in her home town at the Wakefield City Art Gallery. Her first show in the United States was held at Durlacher Bros., New York, in 1949.

Despite the relative isolation of Cornwall, Hepworth and Nicholson kept in touch with friends from their London years, many of whom came to stay: Herbert and Ludo Read, Solly Zuckerman, J.D. Bernal, Peter Gregory, Margaret Gardiner, and John Summerson and his wife, Hepworth's sister Elizabeth. Ben and Barbara continued to enjoy close friendships with Naum and Miriam Gabo, Adrian Stokes and Margaret Mellis, as well as with the painter Peter Lanyon and the potter Bernard Leach, all of whom were living in St. Ives or Carbis Bay. In February 1949, The Penwith Society of Arts in Cornwall was established, with Hepworth, Nicholson, Leach, and Lanyon among the nineteen founding members.

By June 1949, marital relations between Hepworth and Nicholson had broken down, and they were soon living apart. They divorced in February 1951. In early September 1949, she bought Trewyn Studio in St. Ives, with its walled garden, where she lived and worked until her death in 1975 (fig. 12), and which is now the Barbara Hepworth Museum. "It seemed a miracle indeed," she wrote, "to find in the middle of a town a studio with workshops and a yard and garden where nobody objected to the noise of hammering and where there was protection from cold winds so that I could carve out of doors nearly all the year round, and where there was proper space for all the multitudinous items of equipment needed for moving stone and carving it."[46]

fig. 12: Trewyn Studio, St. Ives, January 1959

"Artist in society,"[47] the heading Hepworth assigned to the years 1949-52, in fact describes her life and work during the entire decade of the 1950s. In a mark of official recognition, Barbara was nominated in 1950 to represent Britain at the 25th Venice Biennale. Also in 1950, two sculptures were commissioned for the Festival of Britain. Hepworth designed the sets and costumes for the 1951 production of Sophocles' *Electra* at the Old Vic Theatre, London, and also for Michael Tippett's opera *The Midsummer Marriage*, first performed at the Royal Opera House, Covent Garden, on January 27, 1955. There were retrospective exhibitions of her work in Wakefield in 1951 and at the Whitechapel Art Gallery, London, in 1954. The culmination of this very public decade came in 1959 when Hepworth was awarded the Grand Prix at the 5th São Paulo Bienal.

On several occasions in the 1950s, Hepworth commented on the position of women in the visual arts. She believed that the feminine sensibility or intuition is complementary to the masculine approach, rather than in competition with it.

I think that women will contribute a great deal to this understanding through the visual arts, and perhaps especially in sculpture, for there is a whole range of formal perception belonging to feminine experience. So many ideas spring from an inside response to form; for example, if I see a woman carrying a child in her arms it is not so much what I see that affects me, but what I feel within my own body.[48]

Hepworth visited Greece and the Aegean and Cycladic Islands in August 1954. Of all her writings about landscape, her descriptions of Greece—the mountains, hills, and plains, the architecture and sculpture, and the brilliance and warmth of the Mediterranean light—stand alone in their poetic intensity, verging on the ecstatic. On her return to St. Ives, making use of the enormous logs of scented guarea wood which had recently arrived from Nigeria, Hepworth began working on the first carving inspired by her recent trip to Greece, the 1954-55 *Corinthos* (B.H. 198). Three more carvings with Greek titles were executed in 1955, two of which, like *Corinthos*, had painted white interiors. The Greek experience resurfaced in the early 1960s in two works included in this exhibition: *Curved Form (Oracle)* of 1960 (p. 41) and *Two Forms with White (Greek)* (p. 63) carved in 1963, cast in 1969. Just as the abstract carvings of the mid-1930s represent Hepworth's greatest achievement of that decade, the delicate *Wave* and *Pelagos* the high point of the 1940s, so the massive, almost masculinely powerful, Greek-inspired carvings of the mid-1950s—an extraordinary tour-de-force—are unquestionably her most important group of works in this later period.

As Alan Bowness has pointed out, these magnificent, monumental wood carvings "represent such a definitive statement of the carver's art that in a way it is hardly surprising to find them followed by one of the most radical departures in Barbara Hepworth's development. For in 1956 began the experiments with metal sculpture, first cut and twisted sheets of copper and brass, and then the use of bronze itself."[49]

A sculptor, in working toward bronze, must first make the original in wax, clay, or plaster, from which the molds will be made and from which, in turn, the bronze edition will be cast.

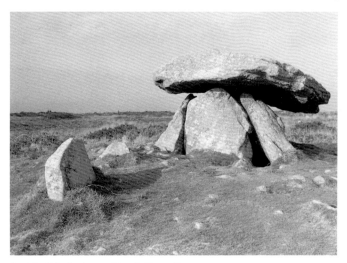

fig. 13: Chûn Quoit, near Morvah, Cornwall
Photo: Alan G. Wilkinson, courtesy Art Gallery of Ontario

Rodin, Degas, and Lipchitz modeled in clay or wax. Hepworth, who hated modeling, worked with plaster, as did Henry Moore. This was a logical extension of their commitment to carving. Hepworth compared creating an armature to building a boat; "... and then putting the plaster on is like covering the bones with skin and muscles. But I build it up so that I can cut it. I like to carve the hard plaster surface."[50] Carving in plaster radically altered the

scope of Hepworth's sculpture in a number of ways. Stylistically, she was able to create more linear, open, transparent forms that would have been impossible to realize in stone or wood. She was also able to work on a much larger scale. Having her sculpture cast in bronze in limited editions meant that she could reach a much larger audience, as many more sculptures were available to museums and private collectors. This change in direction in her work led to the most important commission of her career—to create a large bronze sculpture for the United Nations Headquarters, New York, as a memorial to Secretary-General Dag Hammarskjöld, who was killed in a plane crash on September 18, 1961.

Dag Hammarskjöld and Barbara Hepworth met in 1956. He was a great admirer of her work and the owner of two of her carvings. He had discussed with her the possibility of a large sculpture for the new United Nations Headquarters in New York. Having talked about the size and the kinds of shapes that Hammarskjöld liked, in 1961 Hepworth made the 41-inch high bronze *Single Form (Chûn Quoit)* (B.H. 311), and the 31-inch high walnut *Single Form (September)* (B.H. 312). "Then," she wrote, "when I heard of his death, in a kind of despair, I made the 10-foot high *Single Form (Memorial)* (B.H. 314)."[51] She never dreamt anything further would develop. Hepworth was surprised to hear from U Thant, the new Secretary-General, who wanted to know what she had discussed about the project with Hammarskjöld. In fact, before the Secretary-General's death, a patron, Jacob Blaustein, had been found to cover the cost of the sculpture. Hepworth originally envisaged creating a carving about 8 feet tall, but was persuaded by the engineers at the U.N. that the work should be in bronze, and on a much larger scale.

The 21-foot high *Single Form*, 1962-63 (fig. 1), at the United Nations evolved directly from the three closely related sculptures mentioned above. The first of these, *Single Form (Chûn Quoit)*, includes in the title the name of one of the most impressive Neolithic burial tombs in west Cornwall, located just outside the circular Chûn Castle hill fort, about four miles northwest of Penzance (fig. 13). The shapes and outlines of the relatively flat, leaning, and balancing stones of the mushroomlike Chûn Quoit were clearly the source and inspiration, through memory or association, of Hepworth's 1961 bronze, and therefore the ancestor, several times removed, of the United Nations *Single Form*. (To correct the New York taxi driver, not Turkish, but Celtic and specifically Cornish).

Single Form (fig. 1), was not only the largest sculpture Hepworth had created to date, it was to remain the most monumental work of her career. For me, the brilliance of this great public sculpture—a simple, elegant form, with a single hole, deeply incised lines where the welded joints from the cast bronze sections meet, and an overall surface texture—is that it is totally successful and satisfying on such a vast scale. Some sculptures, when greatly enlarged from smaller studies or maquettes, become pompous and empty, "a little too big for what they have to say," as a curator friend of mine used to observe. Not so with *Single Form*. The soaring, elegant bronze, with its subtly modulated thickness and tapered base, produces an uncanny sensation of weightlessness, as if the sculpture had just gently and effortlessly touched down on its concrete pedestal, encircled by the fountain and pool.

In her address at the unveiling of *Single Form* in New York on June 11, 1964, Barbara Hepworth said:

> Throughout my work on the "Single Form" I have kept in mind Dag Hammarskjöld's ideas of human and aesthetic ideology and have tried to perfect a symbol that would reflect the nobility of his life, and at the same time give us a motive and symbol of both continuity and solidarity for the future. [52]

From 1965 to 1975, the last decade of her career, Barbara Hepworth continued to explore her three basic forms—the standing form, two forms, and the closed form. But in a number of carvings and bronzes she moved on, found new and unexpected sources of inspiration, and created a group of works which, in their scale and complexity, constitute a genuine late style. As Alan Bowness has remarked, in discussing the greatness of the late style of a number of artists, including Henry Moore: "The late work is invariably more private, more centred on the artist's own obsessions, often reverting to much earlier moments of his artistic career or of his life. It is inevitably more difficult to appreciate for the public at large, who may be impressed, without quite understanding why." [53] Characteristic of Hepworth's late style, which is so well represented in this exhibition, are the series of multipart compositions that present vertical and/or horizontal groups of abstract or figurative forms, all more complex and more mysterious than the earlier work. But it is not only more populated groupings that define the late style. It is also the introduction of themes hinting at myth, magic, and fantasy.

Three bronzes of the 1960s are representative of the nostalgic return to earlier sources of inspiration and to new developments. In the 1963 *Square Form with Circles* (p. 43), Hepworth has almost literally translated into three dimensions the squares, rectangles, and circles that characterized Nicholson's painted white reliefs of 1934. The 1966 *Square Forms (Two Sequences)* (p. 45) is surely a homage to Brancusi's *Endless Column*. The 1968 *Six Forms (2x3)* (p. 49) not only announces the

fig. 14: *Fallen Images*, 1974-75, white marble 48 x 51¼ x 51¼", Tate Gallery, London

proliferation of forms found in a number of works from the late period, but also the vertical stacking and balancing of two or more forms—a reinterpretation of one of the major themes of Brancusi's sculpture. This formal innovation is found in the 1967 carving *Three Forms Vertical (Offering)* (B.H. 452) and is the dominant compositional feature of each of the nine bronzes in the group *The Family of Man* (four of which are reproduced in this catalogue).

The white marble *Two Faces* of 1969 (pp. 66-67) will remind anyone who has visited the Barbara Hepworth Museum in St. Ives of the roughly hewn blocks of stone in and around the entrance to the carving studio—all of which have been left untouched since the sculptor's death. For me, *Two Faces* is one of the most moving and

hauntingly beautiful of the late works. The two forms face each other as "quiet as stone," in Keats' phrase, finished but left unfinished, as if to remind us of the arduous and physically demanding process of carving the monolith.

Two large multifigure sculptural groups made in the early 1970s epitomize the style of Hepworth's last years. Each of the nine standing bronze figures that comprise the 1970 *Family of Man* (B.H. 513) has two, three, or four forms stacked on top of one another. Their combined titles suggest the seven ages: *Youth* (p. 69), *Young Girl, Bridegroom* (p. 71), *Bride, Parent I, Parent II* (p. 73), *Ancestor I, Ancestor II* (p. 75), and *Ultimate Form*—which perhaps represents the sculptor's own contribution to the cycle of life. *The Family of Man* established Hepworth once and for all as the sculptor of the upright, standing figure, as Moore was the sculptor of the horizontal, reclining figure. *Conversation with Magic Stones*, 1973 (B.H. 567), of which the maquette is included in this exhibition (p. 93), deals with a more private world. Each of the three large vertical forms is entitled simply *Figure*; each of the three smaller forms is called *Magic Stone*. The latter are as abstract as Hepworth's carvings of the mid-1930s, on which, indeed, they were based. An imaginary dialogue seems to operate on two levels—between the three vertical figures and the magic stones, and between the spectator and the entire sculptural group. In *The Family of Man* and *Conversation with Magic Stones* (B.H. 567), Hepworth presents us with a twentieth-century re-creation of the prehistoric menhirs, quoits, and stone circles that had been a constant source of inspiration since she moved to Cornwall in 1939.

And finally, Hepworth explored the profusion of forms—"a Queen's Bounty," historically, a grant made by the monarch to the mother of triplets—found in the 1972 *Assembly of Sea Forms* (B.H. 555) and the 1974-75 *Fallen Images* (fig. 14). While in the former she assigned different titles to each of the eight forms—a delightful maritime fantasy of *Sea King, Embryo, Sea Mother*—there are no individual titles for the six forms in *Fallen Images*. And yet, by association with her earlier work, the two truncated cones suggest, on an almost subliminal level, two standing figures—a man and a woman. In this composition, one of the last works she completed before she died on May 20, 1975, Barbara Hepworth seems, quite possibly with a sense of finality, to be looking back to the serene, abstract carvings of the mid-1930s, still, as throughout her life, finding fresh interpretations and contexts for familiar forms.

Alan G. Wilkinson, Toronto, August 1996

The author wishes to thank the following for their help and advice:
Prof. A.M. Beattie, Sir Alan and Lady Bowness, Andrea Brown, Alison Farmes, Dr. Murray Frum, Nancy Lockhart, Iain Miller, Nancy Richardson, Graham and Diana Rowley, Sheila Schwartz, Robert Showman, and Anna Wilkinson

Endnotes

1 J.L. Martin, B. Nicholson, N. Gabo, eds., *Circle: International Survey of Constructive Art*, London, 1937, reprinted 1971, p. 121.

2 J.D. Bernal, foreword, *Catalogue of Sculpture by Barbara Hepworth*, exh. cat., Alex. Reid and Lefevre Ltd., London, 1937; quoted in Barbara Hepworth, *Barbara Hepworth: A Pictorial Autobiography*, Tate Gallery, London, 1970 rev. ed., 1978, p. 36.

3 *Barbara Hepworth: A Pictorial Autobiography*, p. 7.

4 Ibid., p. 7.

5 Ibid., p. 9.

6 Alan Bowness, ed., *The Complete Sculpture of Barbara Hepworth 1960-1969*, London, 1971, p. 13.

7 Quoted in Herbert Read, intro., *Barbara Hepworth: Carvings and Drawings*, London, 1952, section 1, n. p.

8 Ibid.

9 *Barbara Hepworth: A Pictorial Autobiography*, p. 13.

10 *Henry Moore*, with photographs by John Hedgecoe, London, 1968, p. 45.

11 See Penelope Curtis and Alan G. Wilkinson, *Barbara Hepworth: A Retrospective*, exh. cat., Tate Gallery, Liverpool, Art Gallery of Ontario, Toronto, 1994, pp. 15-17.

12 *Barbara Hepworth: Carvings and Drawings*, section 1, n. p.

13 Herbert Read, *Art in Britain 1930-40 Centred Around Axis, Circle, Unit One*, exh. cat., Marlborough Fine Art Ltd., London, 1965, p. 7.

14 Ibid., p. 5.

15 *Barbara Hepworth: Carvings and Drawings*, section 1, n. p.

16 Ibid.

17 Ibid., section 2, n. p.

18 Ibid.

19 Quoted in Jeremy Strick, *The Early Work of Barnett Newman: Paintings and Drawings 1944-1949*, exh. cat., PaceWildenstein, New York, 1994, p. 9.

20 *Barbara Hepworth: Carvings and Drawings*, section 2, n. p.

21 J.P. Hodin, *Barbara Hepworth*, Boston, 1961, p. 12.

22 Read, *Art in Britain 1930-40*, p. 5.

23 Herbert Read and H.S. Ede, forewords, *Carvings by Barbara Hepworth, Paintings by Ben Nicholson*, exh. cat., Arthur Tooth and Sons Galleries, London, 1932, n. p.

24 Paul Nash, "A Painter and a Sculptor," *The Week-end Review*, November 19, 1932, p. 613; quoted in *Barbara Hepworth: A Pictorial Autobiography*, p. 22.

25 *Barbara Hepworth: Carvings and Drawings*, section 2, n. p.

26 Ibid.

27 Adrian Stokes, *The Critical Writings of Adrian Stokes: Volume 1, 1930-1937*, London, 1978, p. 310.

28 Quoted in Jeremy Lewison, *Ben Nicholson*, exh. cat., Tate Gallery, London, 1993, p. 216.

29 Quoted in Herbert Read, ed., *Unit One: The Modern Movement in English Architecture, Painting and Sculpture*, London, 1934, p.19.

30 *Barbara Hepworth: Carvings and Drawings*, section 3, n. p.

31 Quoted in Lewison, *Ben Nicholson*, p. 218.

32 *Barbara Hepworth: Carvings and Drawings*, section 3, n. p.

33 Ronald Alley, *Barbara Hepworth*, exh. cat., Tate Gallery, London, 1968, p. 15.

34 Bernal, *Catalogue of Sculpture by Barbara Hepworth*, exh. cat., in *Barbara Hepworth: A Pictorial Autobiography*, p. 36.

35 *Barbara Hepworth: Carvings and Drawings*, section 3, n. p.

36 *Barbara Hepworth: A Pictorial Autobiography*, p. 41.

37 *Barbara Hepworth: Carvings and Drawings*, section 3, n. p.

38 Alan Bowness, intro., *Barbara Hepworth: Drawings from a Sculptor's Landscape*, London, 1966, p. 9.

39 *Barbara Hepworth: A Pictorial Autobiography*, p. 41.

40 *Barbara Hepworth: Carvings and Drawings*, section 4, n. p.

41 Ibid.

42 *Barbara Hepworth: A Pictorial Autobiography*, p. 53.

43 *Barbara Hepworth: Carvings and Drawings*, section 4, n. p.

44 Virginia Woolf, *A Passionate Apprentice: The Early Journals 1879-1909*, Toronto, 1990, p. 282.

45 Bowness, *The Complete Sculpture of Barbara Hepworth 1960-1969*, p. 13.

46 *Barbara Hepworth: Carvings and Drawings*, section 5, n. p.

47 Ibid.

48 *Barbara Hepworth: Carvings and Drawings*, section 6, n. p.

49 Bowness, *Barbara Hepworth: Drawings from a Sculptor's Landscape*, p. 23.

50 Bowness, *The Complete Sculpture of Barbara Hepworth 1960-1969*, p. 7.

51 Ibid., p. 10.

52 *Barbara Hepworth: A Pictorial Autobiography*, p. 96.

53 Alan Bowness, ed., *Henry Moore: Volume 4, Sculpture 1964-73*, London, 1977, pp. 17-18.

Single Form (Dryad), 1945-46, Cornish elm, 76 x 13 ½ x 11″

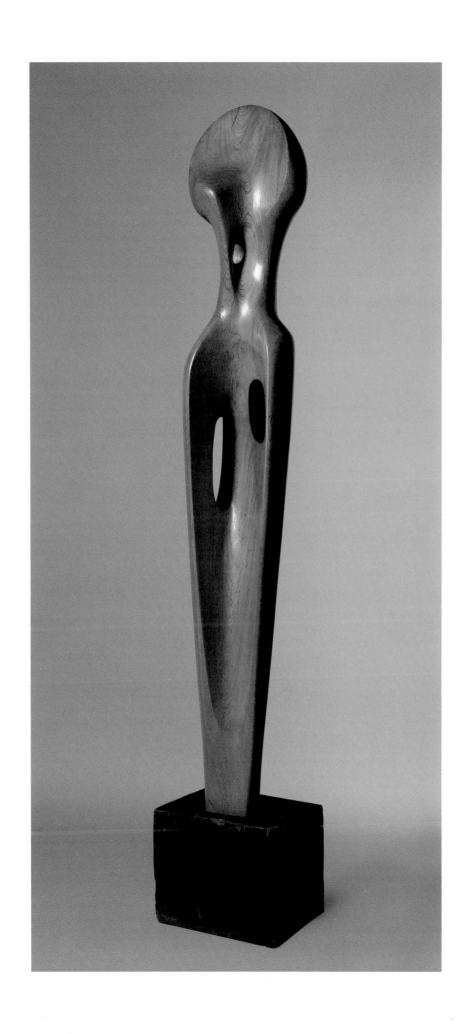

Single Form (Antiphon), 1953, boxwood, 89 x 24 x 24"

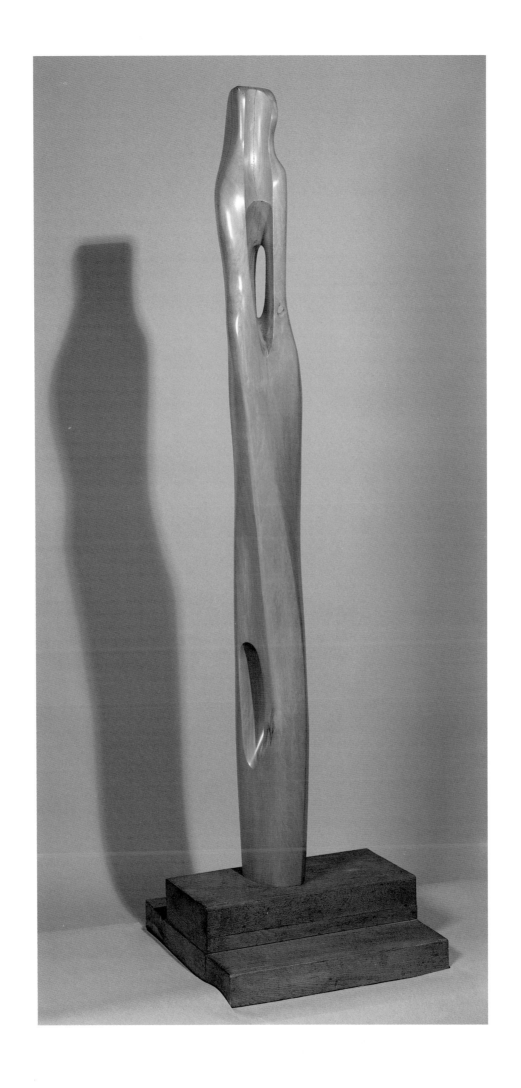

Pierced Form (Toledo), 1957, mahogany and string, 38 x 20 x 18″

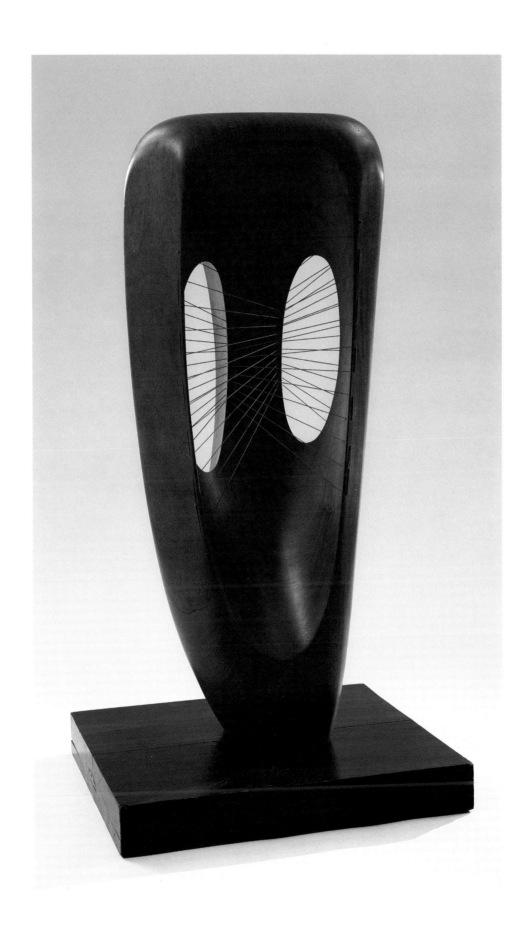

Curved Form (Oracle), 1960, scented guarea, 52 ½ x 31 x 28″

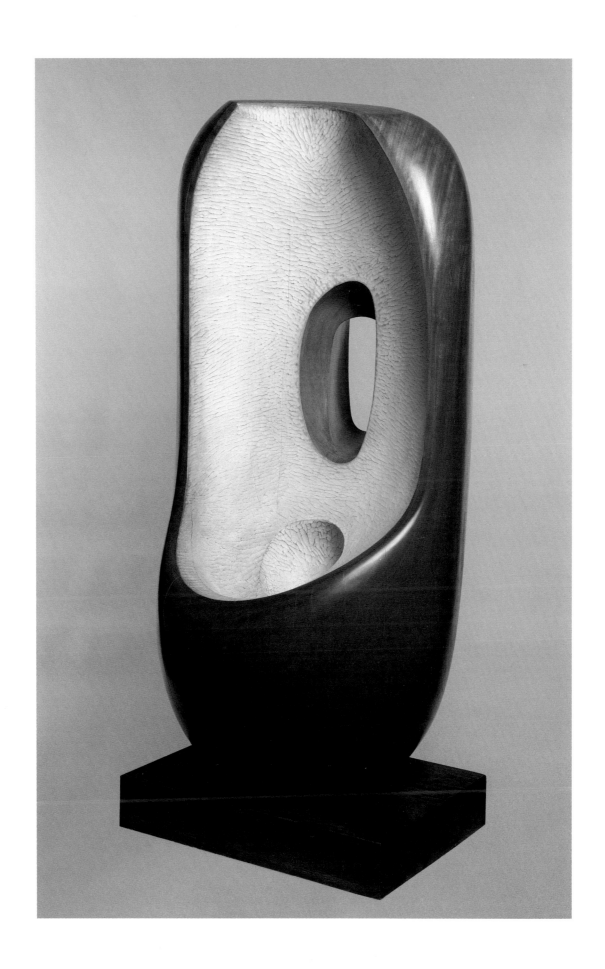

Square Forms with Circles, 1963, bronze, 8′ 6″ x 61 x 28″

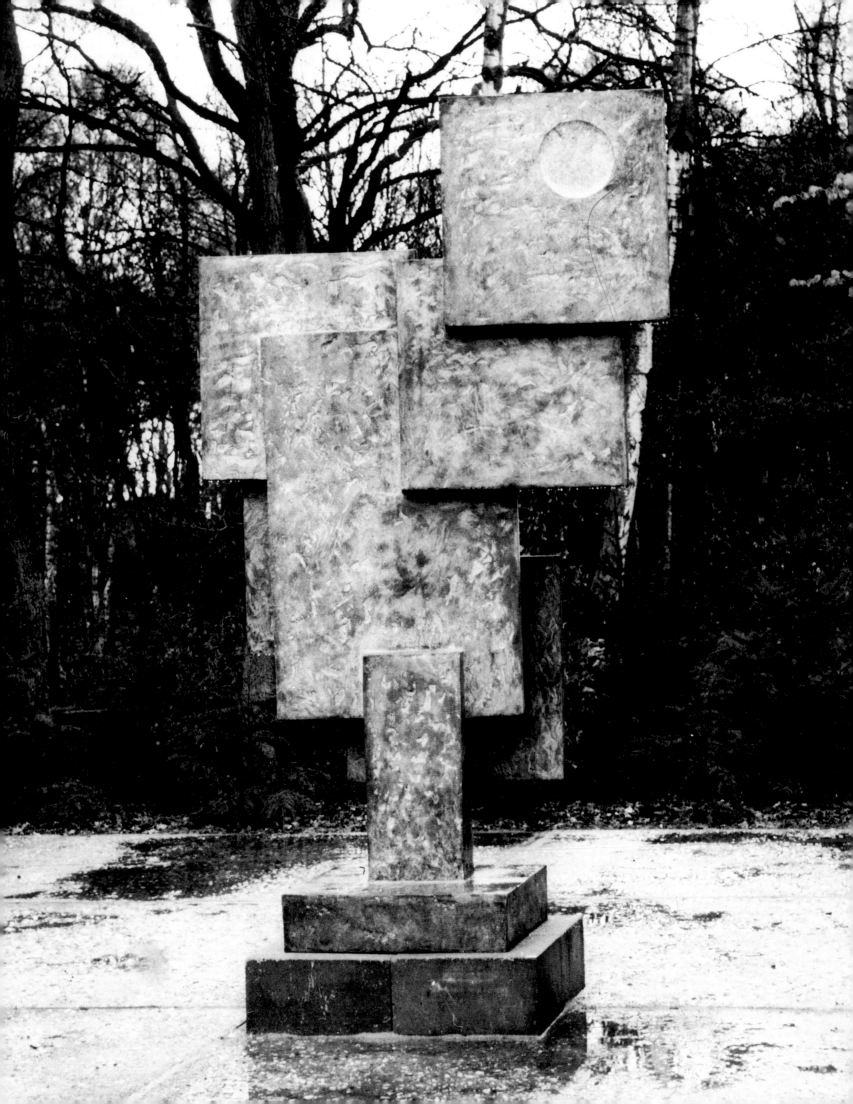

Square Forms (Two Sequences), 1966, bronze, 53 x 19 x 19″

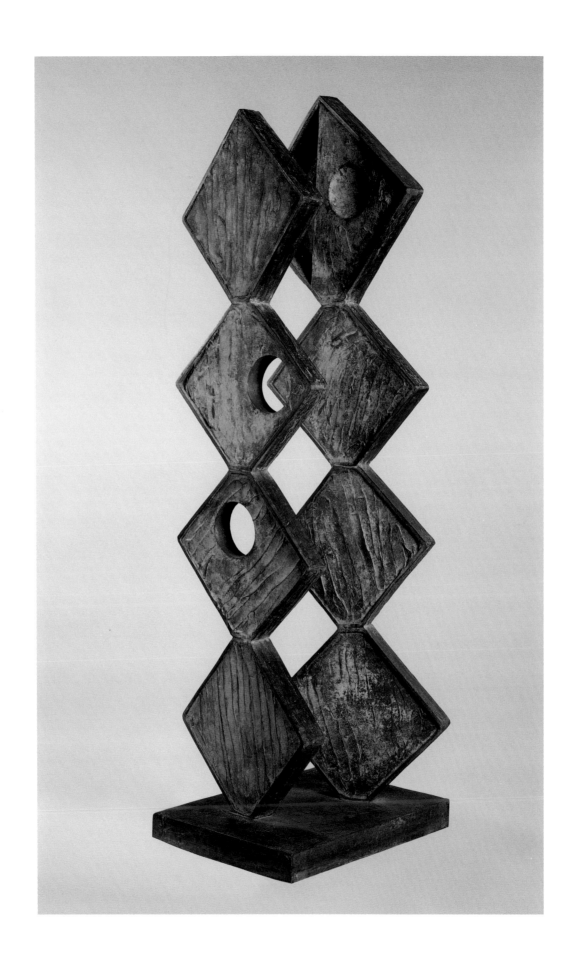

Two Figures, 1968, bronze with color, 8′ 7 ⅞″ x 38 x 59″

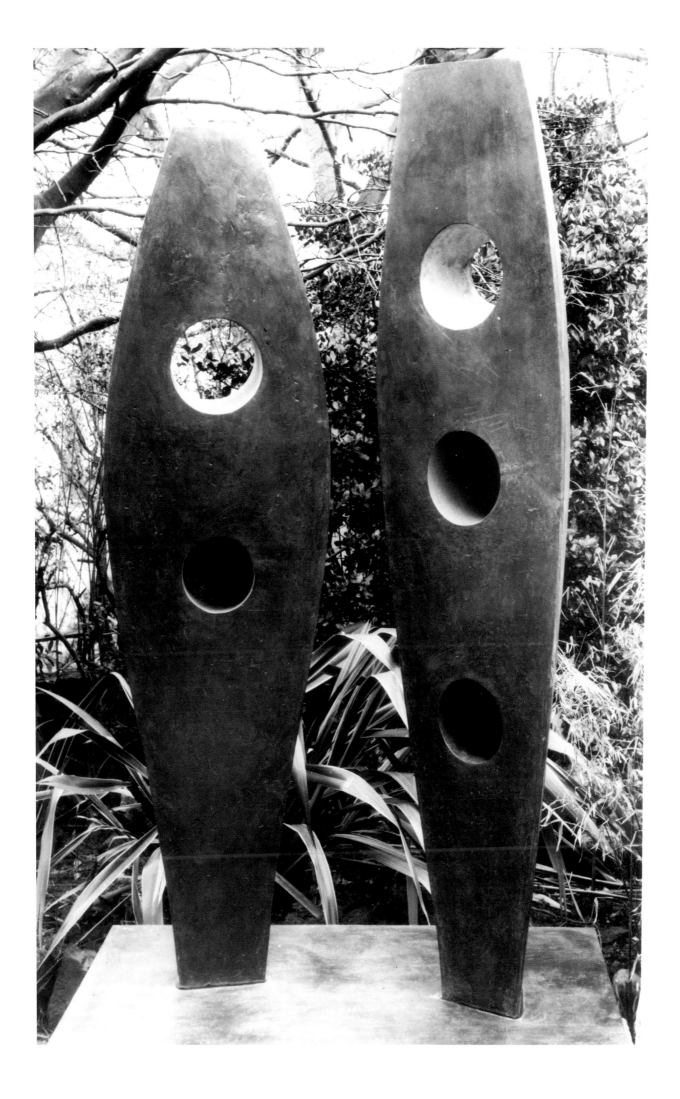

Six Forms (2x3), 1968, bronze, 22 ½ x 34 ½ x 17 ¼"

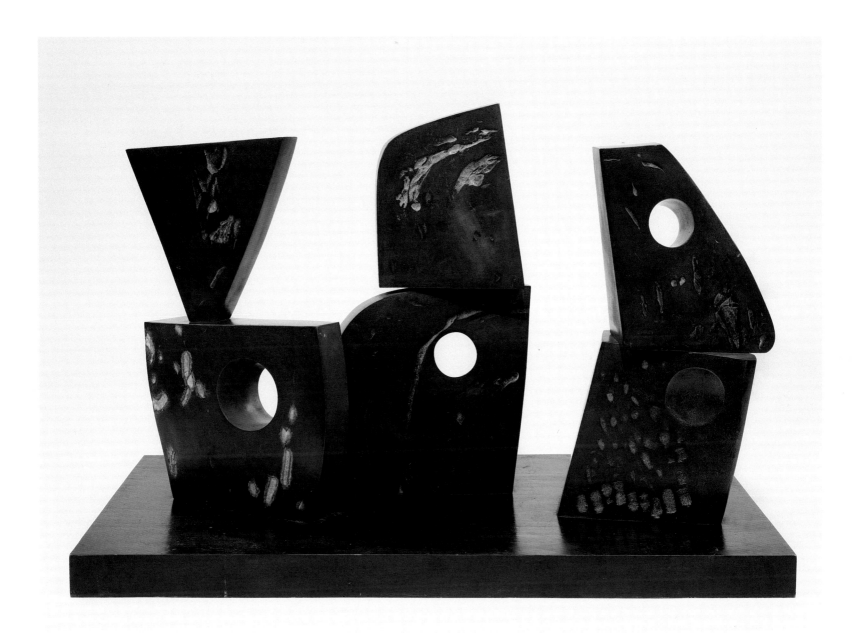

Bird Form, 1963, bronze, 13 ½ x 9 x 10″

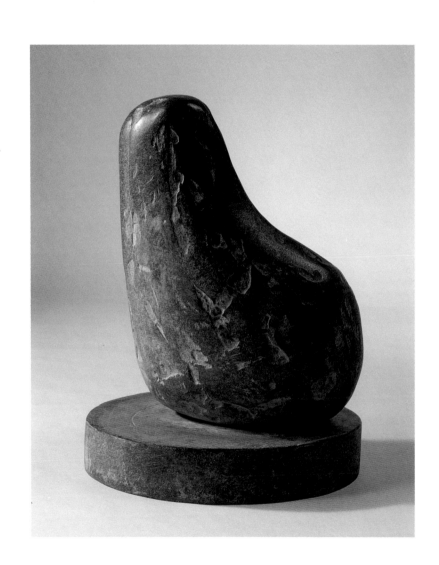

Hollow Form with White Interior, 1963, guarea wood, 41 x 31½ x 14½″

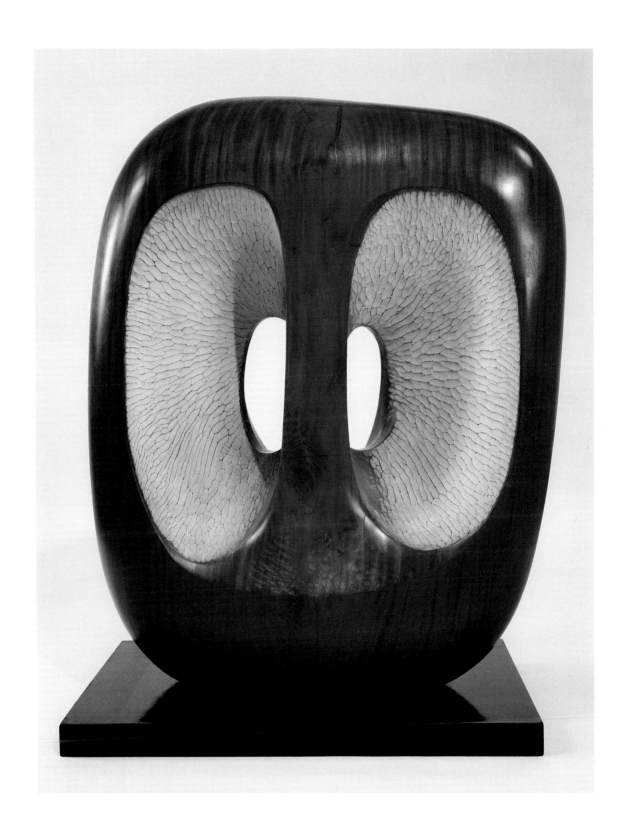

Menhirs, 1964, teak, 49 ½ x 25 ½ x 16″

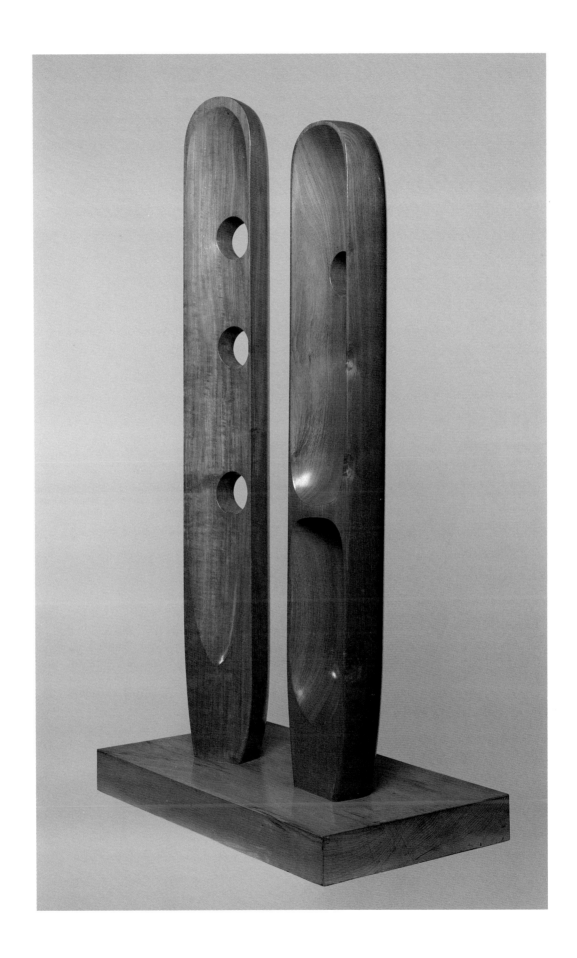

Three Standing Forms, 1965, Roman stone, 72 ½ x 46 x 48″

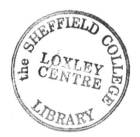

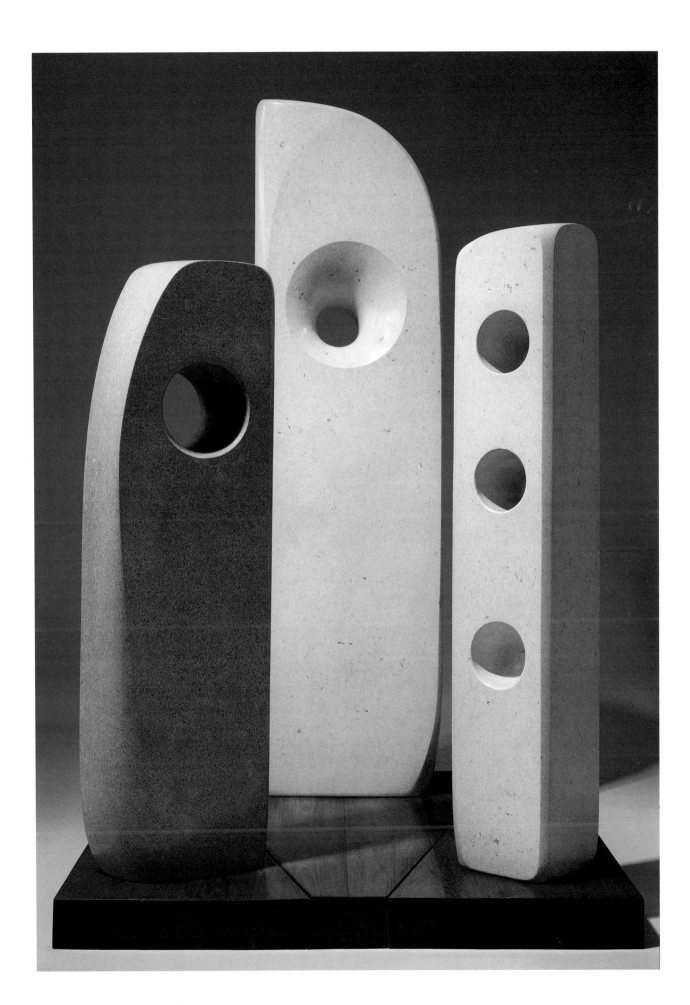

River Form, 1965, American walnut, 33 x 77 x 33"

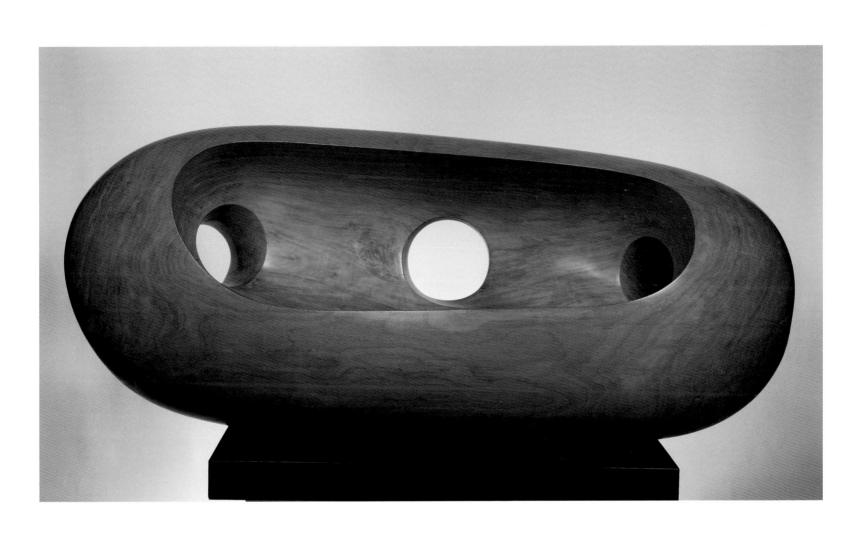

Elegy III, 1966, bronze with color, 55 ½ x 24 x 24″

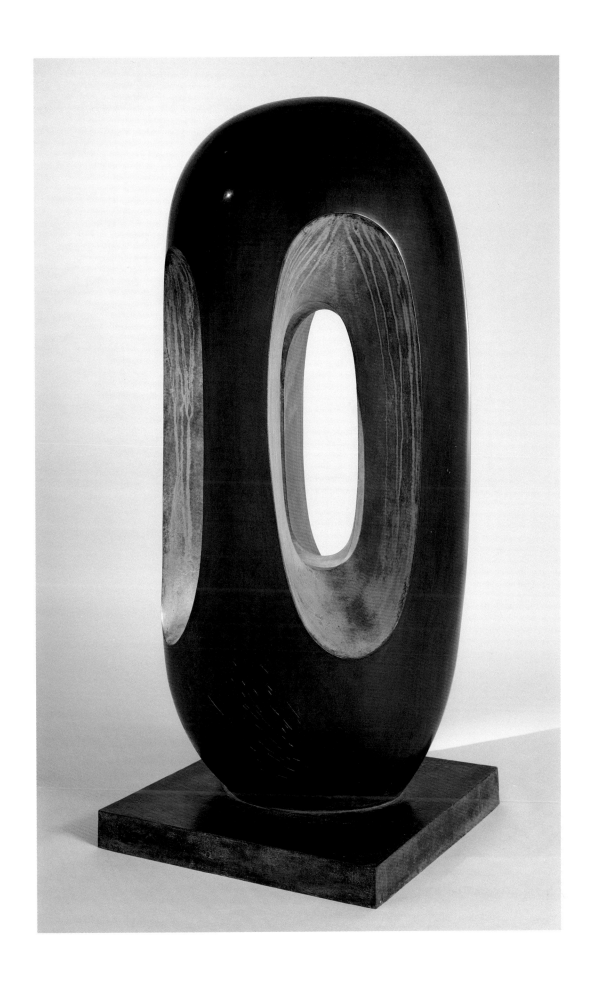

Two Forms with White (Greek), 1969, bronze with white paint, 40 x 48 x 21″

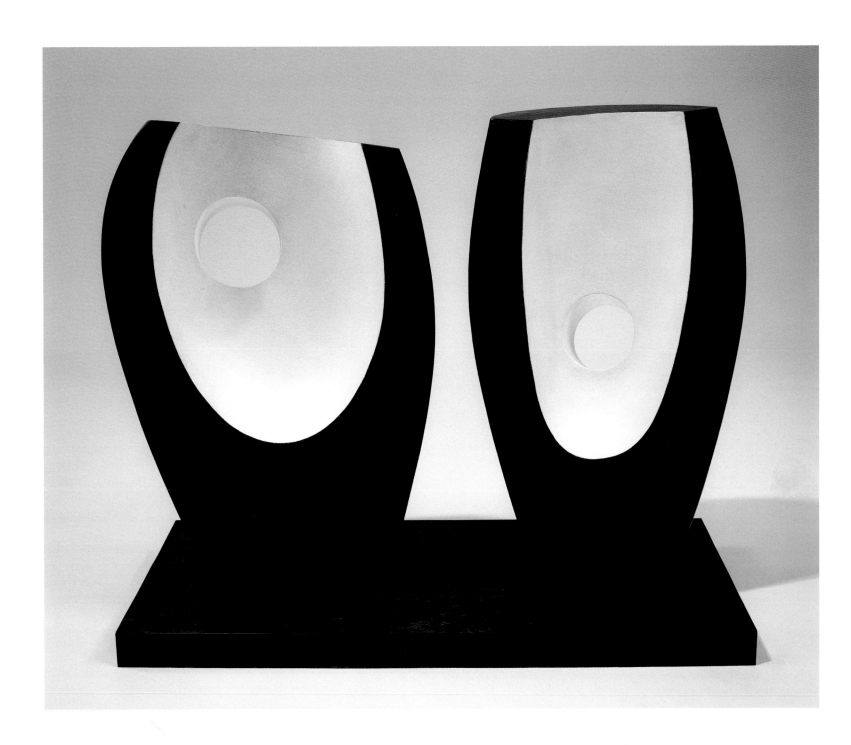

Makutu, 1969, lignum vitae, 31 x 15 x 15″

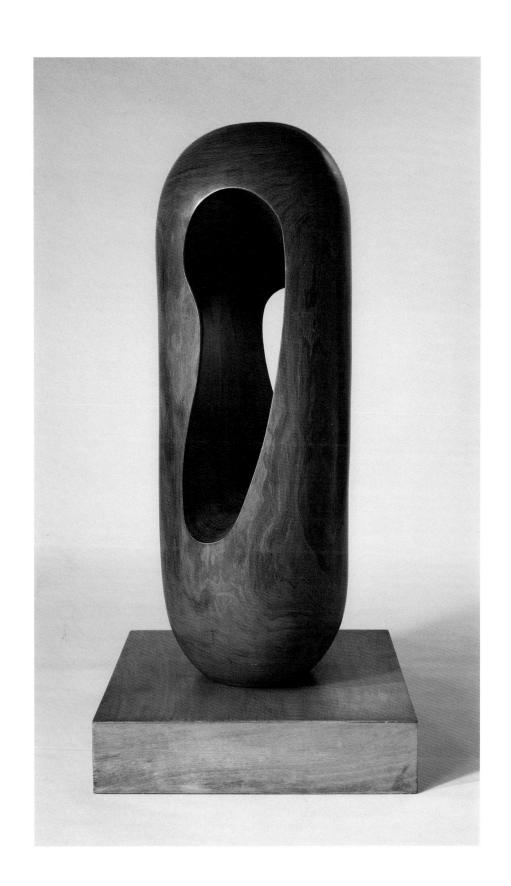

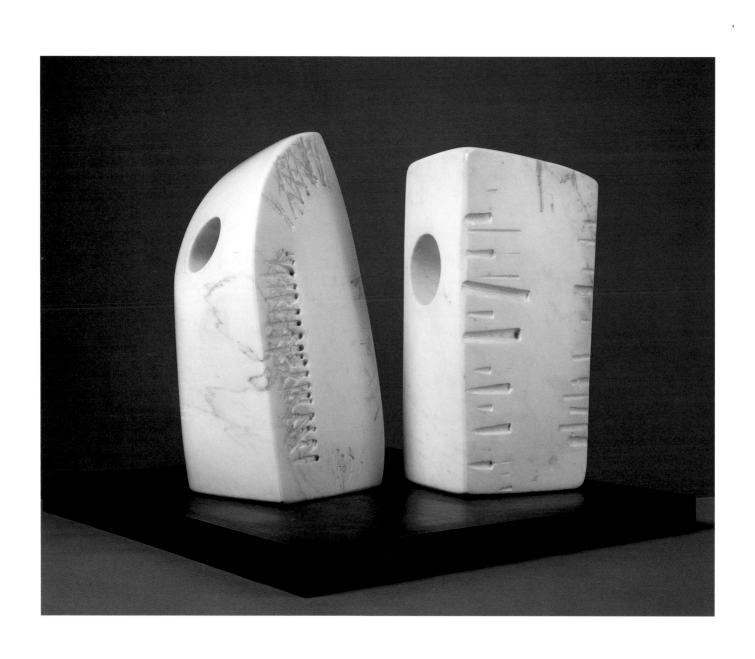

Two Faces, 1969, white marble, 19 ¾ x 24 x 24″

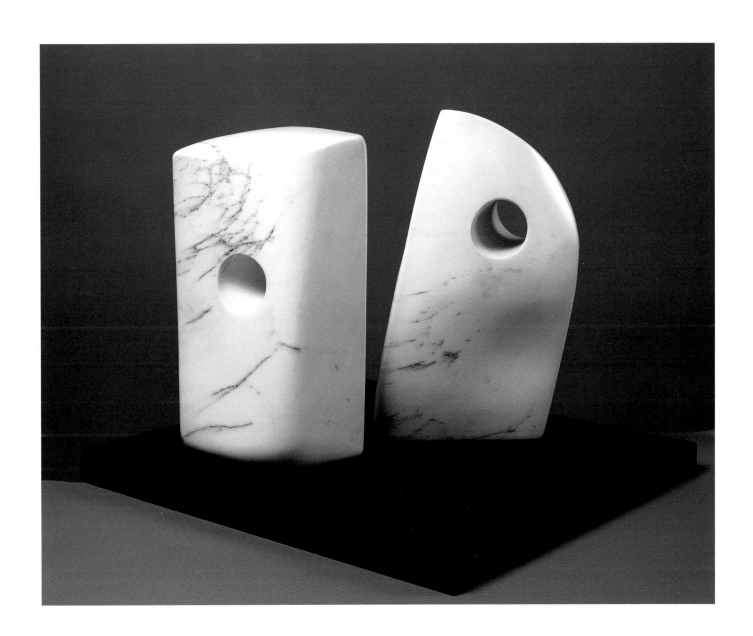

The Family of Man

Youth, 1970, bronze, 80 x 20 x 20″

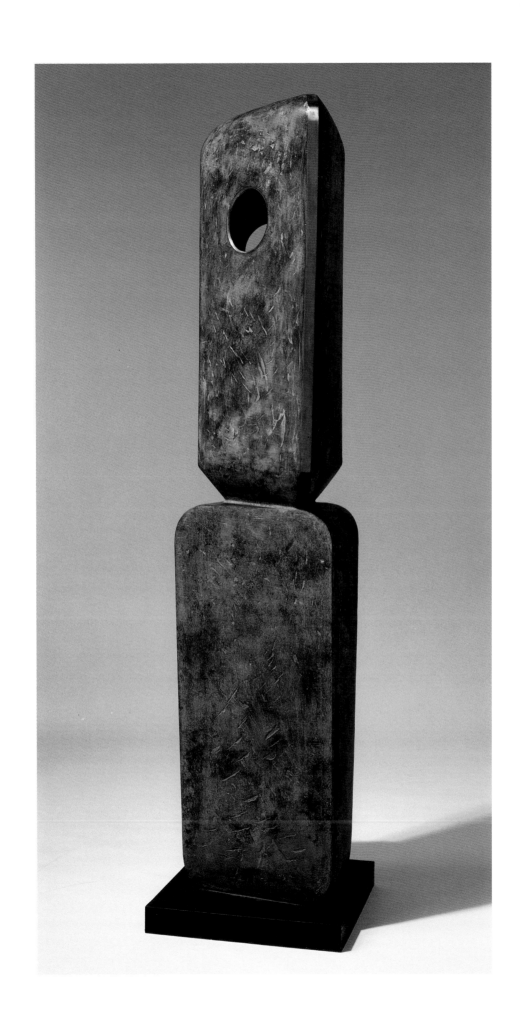

The Family of Man

Bridegroom, 1970, bronze, 8′ 6″ x 38 x 20″

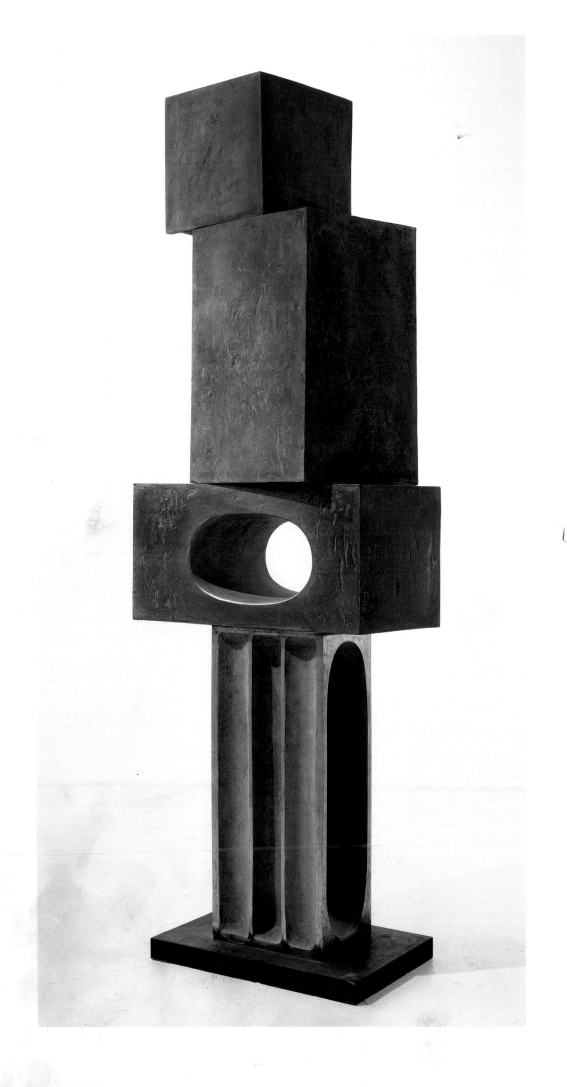

The Family of Man

Parent II, 1970, bronze, 94 x 20 x 30″

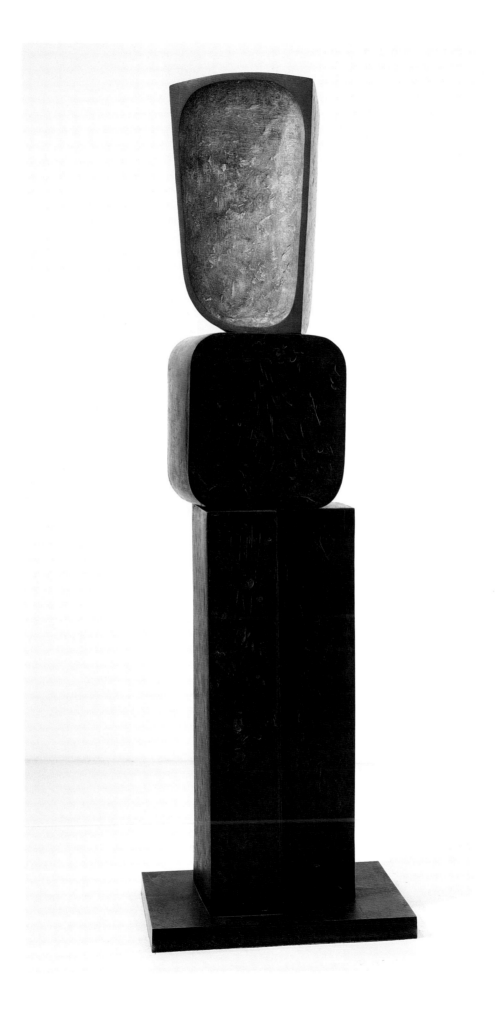

The Family of Man

Ancestor II, 1970, bronze, 9′ 1 ½″ x 30 ¼ x 24″

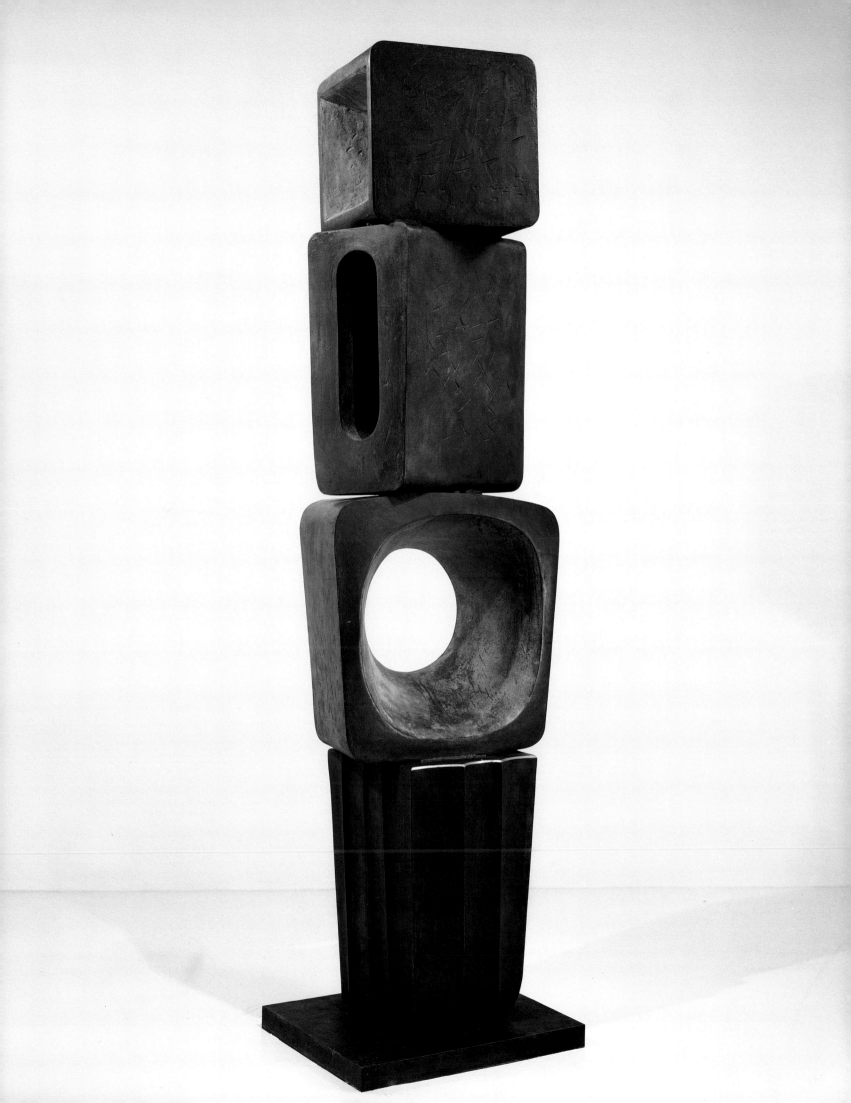

Summer Dance, 1971, bronze, 40 x 54 x 31″

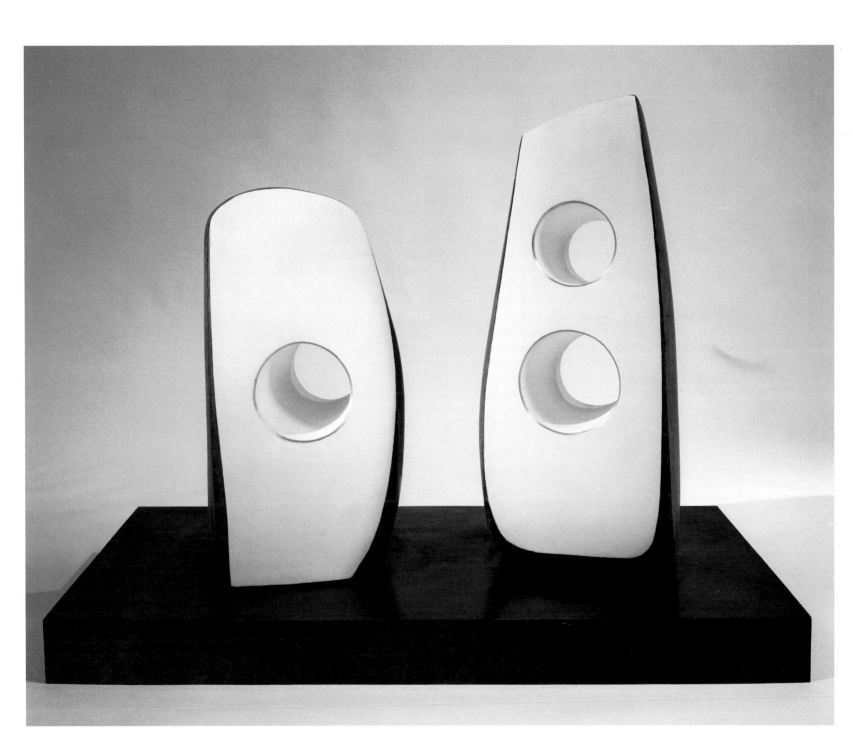

Three Forms in Echelon, 1970, white marble, 26 x 22 x 34"

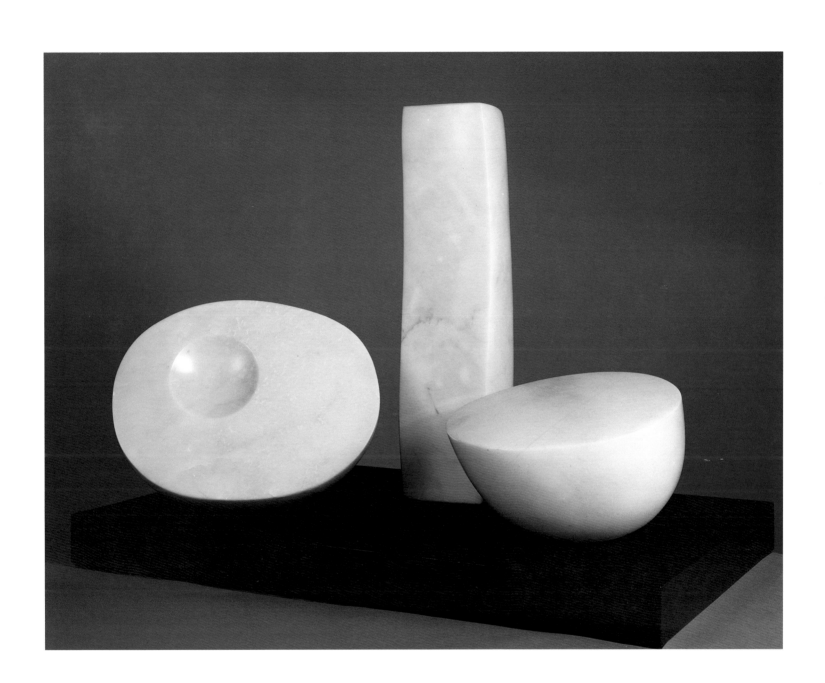

Spring Form in Marble, 1970, Portuguese pink marble, 17 x 20 x 12″

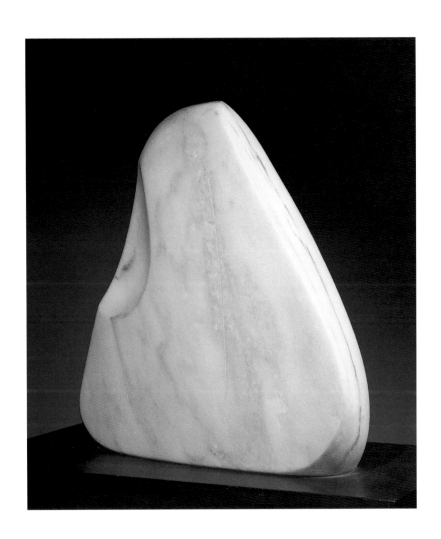

Two Forms (Newborn), 1971, white marble, 22 ½ x 30 ½ x 15 ¼ ″

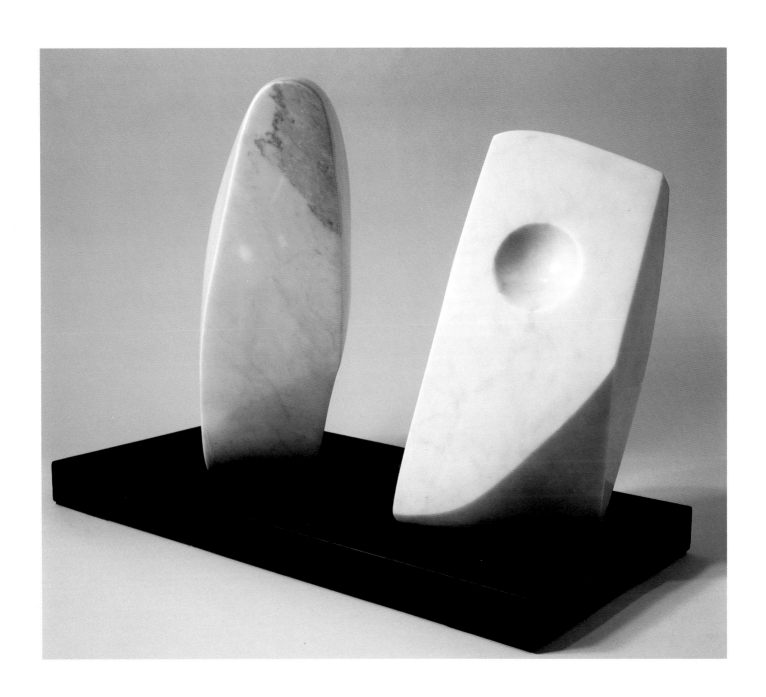

Solitary Form, 1971, white marble, 28 ½ x 24 ⅜ x 20 ⅜"

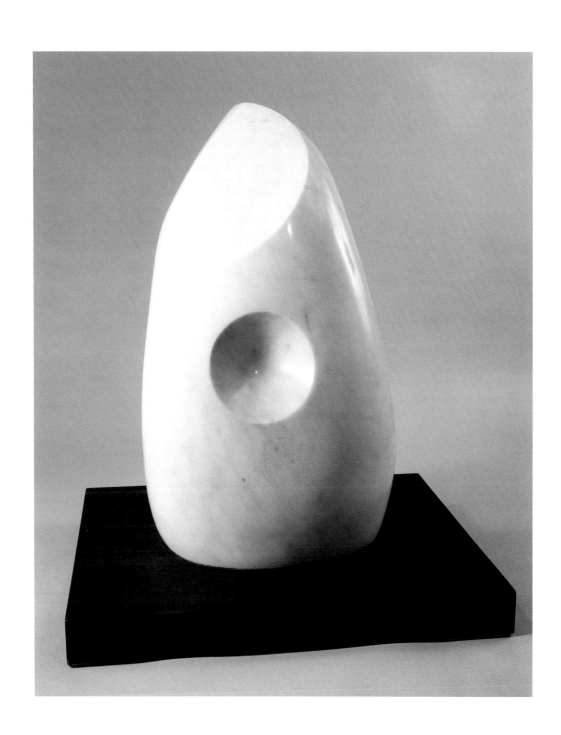

Shaft and Circle, executed 1972, cast 1973, bronze, 48 x 18½ x 12″

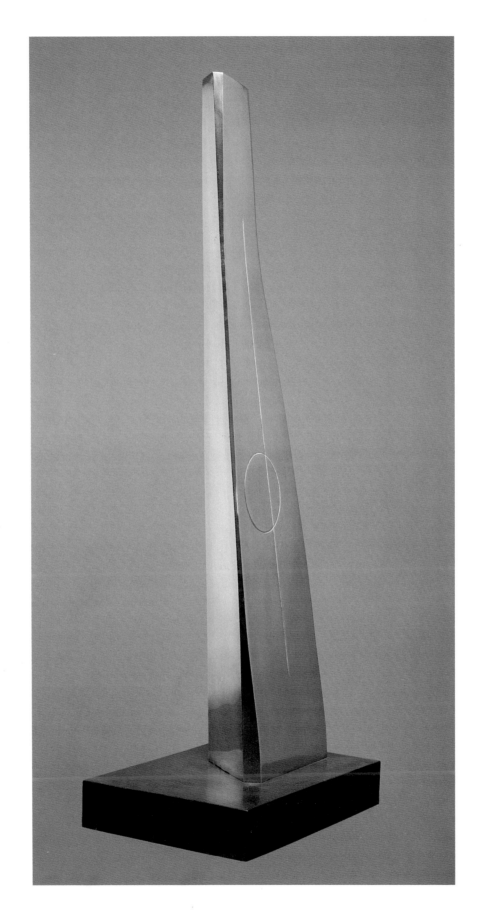

Head (Ra), 1971, bronze, 21 x 22 x 12 ¾″

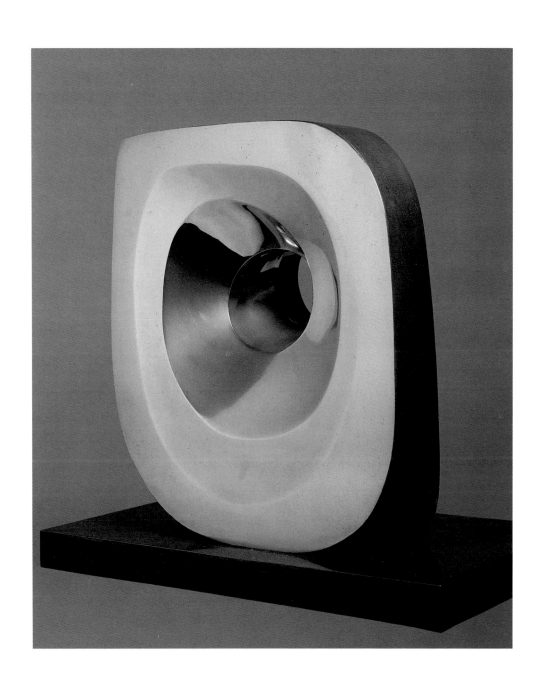

Oval with Two Forms, 1972, polished bronze, 13 x 15 ¼ x 12″

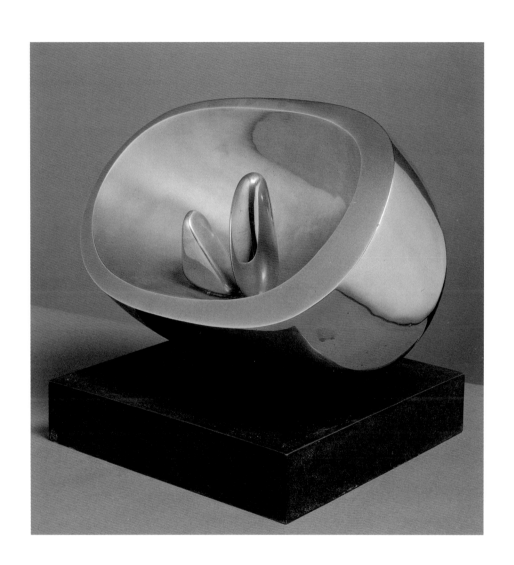

Conversation with Magic Stones (Maquette), 1974, bronze, 13 ½ x 15 ¾ x 13 ¾"

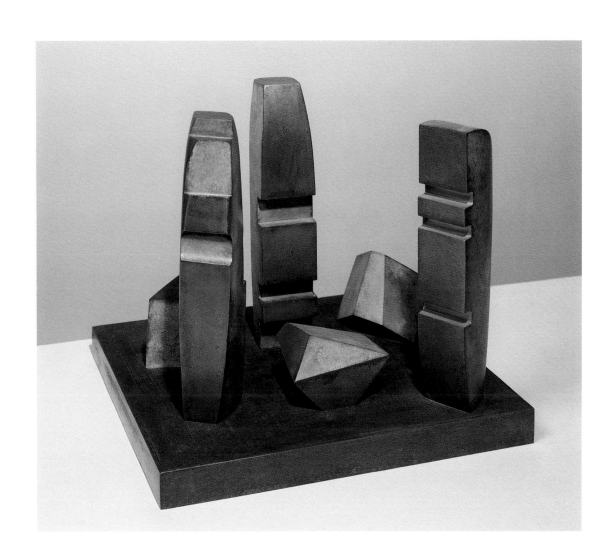

Biography

1903 Born January 10 in Wakefield, Yorkshire, England, the eldest of four children of Herbert R. Hepworth and Gertrude Allison. Educated at Wakefield Girls' High School.

1920 Won a scholarship to the Leeds School of Art, where she first met Henry Moore who was also a student there.

1921 Awarded a county major scholarship and entered the Royal College of Art in London to study sculpture. During vacations she began to carve which was not, at that time, part of the teaching program at the RCA. She had already been to Paris, and was to continue to make regular visits until the outbreak of war in 1939.

1923 Awarded the diploma of the Royal College of Art, and served a further year to compete for the Prix de Rome.

1924 Awarded a scholarship for one year's travel abroad. Left England for Italy in September. Making Florence her headquarters she spent the first months studying Romanesque and Early Renaissance sculpture and architecture in Tuscany. Short visit to Rome in November.

1925 Moved to Siena in January for two months. Married John Skeaping in Florence on May 13, and went to live and work at the British School in Rome where Skeaping was a Rome Scholar in sculpture. They both learned the traditional Italian technique of marble carving from the master-carver Ardini. Returned to England in July for a brief summer vacation, and then went back to Rome.

1926 Returned permanently to England in November, and, with Skeaping, worked for a year in a studio in St. Ann's Terrace, St. John's Wood, London.

1927 Arranged an exhibition of carvings with John Skeaping in their St. John's Wood studio in December. On the recommendation of the sculptor Richard Bedford, George Eumorfopoulos visited the exhibition and bought *Seated Figure* and *Doves*.

1928 Moved to 7 The Mall Studios, Parkhill Road, Hampstead in January, and remained here in this studio which had a garden suitable for working out-of-doors, until 1939. First one-person public exhibition at the Beaux Arts Gallery, London in June.

1929 Son, Paul Skeaping, born August 3.

1930 Spent summer vacation at Happisburgh on the Norfolk coast with John Skeaping and gathered iron-stones on the beach for carving. Henry and Irina Moore were also on holiday with them.

1931 Meets Ben Nicholson, who would become her second husband. In September returned to the Norfolk coast at Happisburgh for a vacation with the Moores and the painter Ivon Hitchens. Joined by Ben Nicholson. At the end of this year the first *Pierced Form* (also called *Abstraction*) was carved.

1932 Elected to the *Seven and Five Society*, with which she exhibits from February until its final show in 1936. Exhibits in Hamburg in June. Brief summer visit to Dieppe with Nicholson, with whom she is now living, having separated from Skeaping. Joint exhibition with Nicholson at Arthur Tooth & Sons Gallery in November, introduction by Herbert Read, now a neighbor and close friend. Hepworth and Nicholson seriously consider moving to Paris.

1933 Divorced from Skeaping in March. With Nicholson, visited Paris and St. Rémy de Provence at Easter. Met Picasso, Braque, Brancusi, and Sophie Tauber-Arp at Arp's studio in Meudon. In Paris during the summer, saw Brancusi again, and met Jean Hélion and his American wife. Invited by Herbin and Hélion to become a member of *Abstraction-Création*, with which she exhibits in Paris during 1933-35. Short visit to Dieppe in September with Nicholson to see Braque, who in turn visits their London studio in October. Second joint exhibition with Nicholson at Reid & Lefevre in October-November.

1934 A founding member of *Unit One*, contributed to the exhibition and publication in April. Triplets Simon, Rachel and Sarah Hepworth Nicholson born on October 3.

1935 In Paris in January, met Mondrian and Kandinsky. Visited Lucerne with Nicholson for the *Thèse, Anti-thèse, Synthèse* exhibition. In the Spring met Gabo in London, a close friendship developed when he moved permanently to London. Work began on the book *Circle*, edited by Nicholson, Gabo and the architect Leslie Martin.

1936 In February exhibits in *Abstract and Concrete* at Oxford and later in London. Met Arp in London on the occasion of the *International Surrealist* exhibition. Began to contribute to Anti-Franco and Anti-Fascist exhibitions. The Museum of Modern Art, New York acquired its first Hepworth, *Discs in Echelon*, 1935, made of padouk wood.

1937 *Circle* published by Faber in July, to coincide with the exhibition *Constructive Art* at the London Gallery which included work by Calder, Gabo, Giacometti, Hélion, Hepworth, Moholy-Nagy, Moore and Nicholson. Calder invites Hepworth and Nicholson to vacation in July-August at his rented house in Varengeville, Dieppe. They visit Braque, and meet Miro who is staying with the American architect, Paul Nelson. One-person exhibition at the Reid & Lefevre Gallery, London in October, introduction by the physicist, J.D. Bernal.

1938 In April showed in the *Abstract Art* exhibition at the Stedelijk Museum, Amsterdam. Mondrian arrives in London in September; Hepworth and Nicholson find him a studio near them in Parkhill Road, Hampstead. He stays for two years until October 1940. On November 17, Hepworth and Nicholson are married when Nicholson obtains a divorce from his first wife, Winifred.

1939 Exhibited at *Living Art in England* at the London Gallery, and in *Abstract and Concrete Art* at Guggenheim Jeune Gallery, London. On August 25, a week before the outbreak of war in Europe on September 3, arrived at St. Ives, Cornwall with her husband and children. Stayed at first with Adrian Stokes at Little Park Owles, then moved to Dunluce, Carbis Bay, St. Ives. Naum Gabo and his wife moved to St. Ives at the same time. During the first three years of the war, ran a nursery school and a small market garden. At night, drew and made small plaster sculptures. No major work possible until 1943.

1940 In November, bombs damage London studio, destroying work left there.

1942 Drawings for Kathleen Raine's *Stone and Flower: Poems 1935-43* (Nicholson & Watson, London, 1943) commissioned. In July moved to a larger house, Chy-an-Kerris, Carbis Bay, St. Ives, where she had a studio and could work in the garden.

1943 First retrospective exhibition, held at Temple Newsam, Leeds in April.

1946 Invited by the London County Council in a limited competition to produce maquettes for four sculptures at the ends of Waterloo Bridge. (No commissions were awarded.) First post-war one-person show at Reid & Lefevre, London in October. Monograph by W. Gibson published by Faber.

1947 First drawings of operating theaters.

1949 Bought Trewyn Studio, in St. Ives, where she lived permanently from 1951 when her marriage to Ben Nicholson was dissolved. Founding member of Penwith Society of Arts in Cornwall. First exhibition in New York, of drawings only, at Durlacher Brothers.

1950 Visited Venice in June, where her work was shown at the 25th Biennale. Two works commissioned for the Festival of Britain: *Contrapuntal Forms* (by the Arts Council of Great Britain), and *Turning Forms* (by the Festival authorities). Both sited March 1951. The Tate Gallery acquired its first Hepworth sculpture, *Bicentric Form*, 1949.

1951 Served on committee of second LCC open-air exhibition of sculpture, held at Battersea Park. Retrospective exhibition held in May at native town of Wakefield, Yorkshire opened by Sir Herbert Read. Executed sets and costumes for the production of Sophocles' *Electra* at the Old Vic Theater, London. *Vertical Forms* commissioned for Hatfield Technical College, Hertfordshire.

1952 Major monograph on her work published by Lund Humphries, London, with an introduction by Sir Herbert Read.

1953 Awarded a second prize in March in Unknown Political Prisoner competition, organized by the Institute of Contemporary Arts, London. Carved *Monolith (Empyrean)* for the London County Council, sited on the South Bank, outside the Royal Festival Hall. Color film on her work, *Figure in Landscape*, produced and directed by Dudley Shaw Ashton. Son, Paul Skeaping, a pilot officer in the RAF stationed in Malaya, died when his plane crashed over Thailand on February 13.

1954 Major retrospective exhibition at Whitechapel Art Gallery, London in April. Visited Greece and the Aegean and Cycladic Islands in August. Executed sets and costumes for Michel Tippett's opera, *The Midsummer Marriage* (first performed at Royal Opera House, Covent Garden, January 27, 1955). In October exhibited with Francis Bacon and William Scott at the Martha Jackson Gallery, New York.

1955-56 Carved large wood sculptures, *Corinthos*, *Delos*, and *Delphi*. Small retrospective exhibition toured United States and Canada, shown in Minneapolis, Nebraska, San Francisco, Buffalo, Toronto, Montreal, Baltimore and New York.

1956 *Theme on Electronics* commissioned for Mullard House, London.

1958 Created CBE in New Year's Honors List in January. *Meridian* bronze (fifteen feet high) commissioned for State House, London. A small monograph on her work, foreword by Professor A. Hammacher, published in English, German and Dutch.

1959 Exhibited at 5th São Paulo Bienal, Brazil in September, won the major award. Visited Paris to complete the work on *Meridian*. Visited New York in October for retrospective exhibition at Galerie Chalette.

1960 Awarded an Honorary Doctorate in Literature, University of Birmingham. Visited Zurich for opening of one-person exhibition at Galerie Charles Lienhard. In March, unveiling of *Meridian*.

1961 Awarded an Honorary Doctorate in Literature, University of Leeds. Major monograph, *Barbara Hepworth, Life and Work*, foreword by Dr. J.P. Hodin, published in English, French and German. BBC Television film produced by John Read: *Barbara Hepworth*, commentary by Barbara Hepworth and Bernard Miles, produced at the artist's studio on Cornwall.

1962 Awarded Lion of Saint Mark Plaque at 5th International Festival of Films on Art at Venice, June 1962. *Winged Figure*, aluminum, nineteen feet three inches high, commissioned for John Lewis Partnership Limited, London. Major retrospective of work done from 1952 to 1962 at Whitechapel Art Gallery, London in May.

1963 *Single Form*, bronze, twenty-one feet high, commissioned for United Nations, New York. Exhibited at 7th Biennale, Tokyo, Japan, awarded the *Foreign Minister's Award*. Monograph, *Barbara Hepworth*, in Art in Progress Series, foreword by Michael Shepherd, statement by the artist.

1964 Visited New York in June for the unveiling of *Single Form*, the memorial to Dag Hammarskjöld for the United Nations, gifted by the Jacob and Hilda Blaustein Foundation. Ceremony performed by the Secretary-General, June 11, 1964. Visited Copenhagen in September for the opening of a one-person exhibition touring Scandinavia organized by The British Council. Also visited Backakra in Sweden to see the Dag Hammarskjöld Museum there.

1965 Visited Holland in May for the opening of a retrospective exhibition of sculpture and drawings at Rijksmuseum Kröller-Müller, Otterlo, on the occasion of the opening of the new Rietveld Pavilion there. Created DBE in Queen Elizabeth's Birthday Honors List. Became a Trustee of the Tate Gallery, London in September.

1966 Awarded an Honorary Doctorate in Literature, University of Exeter. Showed at Fifth International Sculpture Exhibition at Sonsbeek. Diagnosed to have throat cancer; cared for by specialist Stanley Lee at Westminster Hospital, London. Monograph, *Barbara Hepworth Drawings*, with an introduction by Alan Bowness, published by Corn, Adams and Mackay.

1967 TV film by Westward Television with score by Benjamin Britten. Breaks femur in Scilly Isles in June. Gives nine sculptures to Tate Gallery in December [had previously given four sculptures and two drawings in 1964]. In correspondence with Dean Hussey at Chichester Cathedral over commission for *Crucifixion*.

1968 Film by Central Office of Information for international distribution. Major retrospective exhibition at Tate Gallery, London in April and May. Elected Honorary Fellow of St. Anne's College, Oxford in April. Awarded Honorary Doctorate in Literature, University of Oxford. Invested as a Bard of Cornwall, and received the conferment of Freedom of the Borough of St. Ives in September.

1969 Tate planning an archive of 20th century art, director asked Hepworth, Moore and Nicholson to commit their papers.

1970 Published *Barbara Hepworth: A Pictorial Autobiography*, London 1970. Awarded Grand Prix at *Salon international de le femme*, Nice, by the Prefect of the Alpes-Maritimes. Made Senior Fellow of Royal College of Art, London in July, and Honorary Doctorate in Literature, University of London in November.

1971 Arts Council traveling exhibition in Britain. Curwen Gallery shows new suite of nine lithographs (*Aegean Suite*). Awarded Honorary Doctorate in Literature, University of Manchester in May. *The Complete Sculpture of Barbara Hepworth 1960-69*, edited by Alan Bowness, published by Lund Humphries, London.

1972 Exclusive Agency with Marlborough Fine Art. Marlborough Fine Art, London shows *The Family of Man*. End of term as Tate Gallery Trustee.

1973 *Theme and Variations*, three-part bronze relief, unveiled at Cheltenham. Elected Honorary Member of the American Academy of Arts and Letters.

1975 Died May 20, aged 72, in a fire at her studio in St. Ives.

1976 Opening of Barbara Hepworth Museum, St. Ives.

This biography is based on that made by the artist herself, revised by Alan Bowness, August 1996.

Solo Exhibitions

1928 (with William Morgan and John Skeaping), Beaux Arts Gallery, London.

1930 (with John Skeaping), Arthur Tooth & Sons Gallery, London.

1932 (with Ben Nicholson), Arthur Tooth & Sons Gallery, London.
Introduction by Herbert Read.

1933 (with Ben Nicholson), Alex. Reid & Lefevre Gallery, London.

1937 Alex. Reid & Lefevre, London. Introduction by J. D. Bernal.

1943 *Retrospective* (with Paul Nash), Temple Newsam, Leeds. Introduction by Philip Hendy.

1944 Wakefield City Art Gallery, Wakefield. Introduction by Herbert Read.
The exhibition traveled to Bankfield Museum, Halifax, 1944.

1946 The Lefevre Gallery, London.

1948 Alex. Reid & Lefevre Gallery, London.

1949 *Drawings*, Durlacher Brothers, New York.

1950 *New Sculpture and Drawings*, The Lefevre Gallery, London.
Retrospective, XXV Biennale, Venice. Introduction by David Lewis.

1951 *Sculpture and Drawings*, Wakefield City Art Gallery, Wakefield. The exhibition traveled to Manchester City Art Gallery, Manchester; and York. Introduction by Patrick Heron.

1952 *New Sculpture and Drawings*, The Lefevre Gallery, London.

1954 *Retrospective Exhibition of Carvings and Drawings from 1927-1954*, Whitechapel Art Gallery, London. Introduction by David Baxandall.

1955-56 *Carvings and Drawings, 1937-1954*, organized by Martha Jackson Gallery, New York. Traveled to Walker Art Center; The University of Nebraska Art Galleries; San Francisco Museum of Art; The Albright Art Gallery; The Art Gallery of Toronto; The Montreal Museum of Fine Arts; and The Baltimore Museum of Art. Introduction by Herbert Read.

1956 *Recent Works*, Gimpel Fils Gallery, London.

1956-57 *Sculpture, Paintings, Drawings*, Martha Jackson Gallery, New York.

1958 *Recent Works*, Gimpel Fils Gallery, London.

1959 Galerie Chalette, New York. Introduction by Herbert Read.

1959-60 Exhibition organized by the British Council. Traveled to V Bienal do Museu de Arte Moderna, São Paulo; Comision National de Bellas Artes, Montevideo; Museo Nacional de Bellas Artes, Buenos Aires; Instituto de Arte Moderno, Santiago; and Museo de Bellas Artes, Caracas. Introduction by J.P. Hodin.

1960 Galerie Charles Lienhard, Zurich. Introduction by J.P. Hodin.

1961 Gimpel Fils Gallery, London.

1961 *An Exhibition of Photographs of Sculpture and Drawings with some Original Bronzes*, arranged by the British Council, London. Traveled to Ceylon, New Zealand, Hong Kong, Sarawak, Vietnam, Thailand and Malaya. Introduction by Alan Bowness.

1962 *Abstract Form and Life: Sculpture and Biological Models*, Queen's University of Belfast Visual Arts Group, Belfast.

1962 *An Exhibition of Sculpture from 1952-1962*, Whitechapel Art Gallery, London. Introduction by Bryan Robertson.

1963 *Sculpture and Drawings*, John Lewis Auditorium, London.

1963-64 *Sculpture and Drawings*, Gimpel-Hanover Galerie, Zurich.

1964 *Sculpture and Drawings*, Gimpel Fils Gallery, London.

1964-65 Kunstforeningen, Copenhagen. Exhibition organized by British Council. Traveled to Moderna Museet, Stockholm; Ateneum, Helsinki; and Kunstnernes Hus, Oslo. Introduction by J.P. Hodin.

1965-66 *Beeldhouwwerken en tekeningen*, Rijksmuseum Kröller-Müller, Otterlo. The exhibition traveled in reduced form to Kunsthalle Basel; Galleria Civica d'Arte Moderna, Turin; Karlsruhe and Essen.

1966 Marlborough-Gerson Gallery Inc., New York. Introduction by Herbert Read.

Gimpel Fils Gallery, London.

1968 The Tate Gallery, London. Essays by Ronald Alley, Nicolete Gray, and R.W.D. Oxenaar.

1969 Gimpel-Weitzenhoffer Gallery, New York.

Twelve Lithographs, Curwen Gallery, London.

1970-71 *Sculpture and Lithographs*, Arts Council of Great Britain. Traveled throughout Britain.

1970 *Recent Work: Sculpture, Paintings, Prints*, Marlborough Fine Art Ltd., London. Introduction by Adrian Stokes.

Exhibition, 1970, Hakone Open-Air Museum, Hakone, Japan. Traveled to Kyoto, Osaka and Tokyo, Japan.

City Art Gallery, Plymouth. Introduction by Edwin Mullins.

Nice. Exhibition to coincide with the Award of Grand Prix as Woman Artist of the Year given by the Prefect of the Alpes-Maritimes.

1971 *The Aegean Suite: Nine Lithographs*, Curwen Gallery, London.

Gimpel-Weitzenhoffer Gallery, New York. Introduction by Dr. Joel Hurstfield.

Archer M. Huntington Gallery, University of Texas Art Museum, Austin.

1972 *The Family of Man - Nine Bronzes and Recent Carvings*, Marlborough Fine Art Ltd., London. Introduction by A.M. Hammacher.

Gimpel Fils Gallery, London.

1973 Marlborough-Godard Gallery, Toronto.

1974 *'Conversations'*, Marlborough Gallery, New York. Introduction by Dore Ashton.

1975 Marlborough Galerie AG, Zurich.

William Darby Gallery, London.

Gimpel Fils Gallery, London.

1976 *Opening Exhibition*, Barbara Hepworth Museum, St. Ives, Great Britain.

Late Works on Loan from the Trustees of the Barbara Hepworth Estate, Royal Botanic Garden, Edinburgh. Introduction by Douglas Hall.

1977 Gimpel & Weitzenhoffer, New York.

1978 Gallery Kasahara, Osaka, Japan.

A Selection of Small Bronzes and Prints, organized by The Scottish Arts Council. Traveled to Scottish College of Textiles, Galashiels; Museum and Art Gallery, Inverness; Museum and Art Gallery, Dundee; Lillie Art Gallery, Milngavie; Museum and Art Gallery, Hawick; and Maclaurin Art Gallery, Ayr. Introduction by Douglas Hall.

1979 *Carvings and Bronzes*, Marlborough Gallery, New York. Introduction by Nicolas Wadley.

1980 Yorkshire Sculpture Park, West Bretton, Yorkshire. Introduction by Andrew Causey and R.W.D. Oxenaar.

1982 *Carvings*, Marlborough Fine Art Ltd., London. Introduction by Moelwyn Merchant.

Storm King Art Center, Mountainville, New York.

1982-83 *A Sculptor's Landscape 1934-1974*, Swansea Art Gallery and Museum. Traveled to Bangor, Wrexham and Isle of Man.

1985 *Early Life*, Wakefield Art Gallery, Wakefield, Great Britain.

Late Carvings, Elizabethan Exhibition Gallery, Wakefield, Great Britain.

1987-88 *Ten Sculptures* 1951 - 1973, New Art Centre, London.

1991-92 The Art Gallery of Ontario Collection, Art Gallery of Ontario, Toronto. Traveled to Art Gallery of Algoma, Sault Ste. Marie, and throughout Canada. Introduction by Alan Wilkinson.

1994 *Lithographs Made at Curwen Studio 1969 and 1971*, Curwen Gallery, London.

Gimpel Fils, London.

1994-95 *A Retrospective*, Tate Gallery, Liverpool. The exhibition traveled to Yale Center for British Art, New Haven; and Art Gallery of Ontario, Toronto.

Monographs

Barbara Hepworth: Sculptress; with an introduction by William Gibson; collected and edited by Lillian Browse. London: Faber and Faber, 1946.

Barbara Hepworth: Carvings and Drawings; with an introduction by Herbert Read. London: Lund Humphries, 1952.

A. M. Hammacher. *Barbara Hepworth*. London: A. Zwemmer, 1958.

J. P. Hodin. *Barbara Hepworth*. London: Lund Humphries; Neuchatel: Editions du Griffon, 1961. With a complete catalogue of sculptures 1925-59 by Alan Bowness.

Michael Shepherd. *Barbara Hepworth*. London: Methuen, 1963.

The Unveiling of 'Single Form' by Barbara Hepworth, Gift of Jacob Blaustein after a Wish of Dag Hammarskjöld. New York: United Nations, 1964.

Barbara Hepworth: Drawings from a Sculptor's Landscape; with an introduction to the drawings by Alan Bowness. London: Cory, Adams & Mackay, 1966.

A. M. Hammacher. *Barbara Hepworth*. London: Thames and Hudson, 1968. Revised edition, 1987.

Barbara Hepworth: a Pictorial Autobiography. Bath: Adams and Dart, 1970. Revised editions, 1978 and 1985.

The Complete Sculpture of Barbara Hepworth 1960-69, edited by Alan Bowness. London: Lund Humphries, 1971.

Alan Bowness. *A Guide to the Barbara Hepworth Museum*. St. Ives: Trewyn Studio and Garden, 1976. Reprinted in 1984.

Barbara Hepworth: A Guide to the Tate Gallery Collection at London and St. Ives, Cornwall; introduction by David Fraser Jenkins. London: Tate Gallery, 1982.

Margaret Gardiner. *Barbara Hepworth: a Memoir*. Edinburgh: Salamander Press, 1982. New edition published in 1994 by Lund Humphries, London.

Sally Festing. *Barbara Hepworth: a Life of Forms*. London: Viking, 1995.

Barbara Hepworth: Reconsidered, edited by David Thistlewood. Liverpool: University Press and Tate Gallery, 1996.

Selected Public Collections

Abbot Hall Art Gallery, Kendal, Great Britain

Aberdeen Art Gallery, Aberdeen, Great Britain

Albright-Knox Art Gallery, Buffalo, New York

Art Gallery of Hamilton, Hamilton, Canada

Art Gallery of New South Wales, Sydney, Australia

The Art Gallery of Ontario, Toronto, Canada

Art Gallery of Western Australia, Perth, Australia

The Art Institute of Chicago, Chicago, Illinois

Arts Council Collection, Great Britain

Auckland City Art Gallery, Auckland, New Zealand

Australian National Gallery, Canberra, Australia

Barbara Hepworth Museum and Sculpture Garden, St. Ives, Great Britain

The Barber Institute of Fine Arts, University of Birmingham, Birmingham, Great Britain

Birmingham Museum and Art Gallery, Birmingham, Great Britain

Bolton Museum and Art Gallery, Bolton, Great Britain

Bournemouth and Poole College of Art and Design, Dorset, Great Britain

Bridgestone Museum of Art, Tokyo, Japan

Bristol City Museum and Art Gallery, Bristol, Great Britain

British Council Collection, Great Britain

British Museum, London, Great Britain

Castle Museum, Norwich, Great Britain

Cecil Higgins Art Gallery and Museum, Bedford, Great Britain

City Museum and Art Gallery, Portsmouth, Great Britain

Classic Hall Galleries, Hanover College, Hanover, Indiana

Columbus Museum of Art, Columbus, Ohio

Cornwall County Council, Great Britain

Dag Hammarskjöld Museum, Backakra, Sweden

Dallas Museum of Art, Dallas, Texas

The Detroit Institute of Arts, Detroit, Michigan

Didrichsen Taidemuseo, Helsinki, Finland

Everson Museum of Art, Syracuse, New York

Exeter City Museum and Art Gallery, Exeter, Great Britain

Ferens Art Gallery, Hull, Great Britain

Fitzwilliam Museum, Cambridge, Great Britain

Fondation Maeght, St. Paul-de-Vence, France

Fred Jones Jr. Museum of Art, University of Oklahoma, Norman, Oklahoma

Glynn Vivian Art Gallery and Museum, Swansea, Great Britain

Government Art Collection of the United Kingdom

Haags Gemeentemuseum, The Hague, The Netherlands

Hakone Open-Air Museum, Hakone, Japan

Harvard University, Cambridge, Massachusetts

Herbert Art Gallery and Museum, Coventry, Great Britain

Hirshhorn Museum and Sculpture Garden, Smithsonian Institution, Washington, D.C.

Indiana University Art Museum, Bloomington, Indiana

Indianapolis Museum of Art, Indianapolis, Indiana

Ipswich Museum, Ipswich, Great Britain

Israel Museum, Jerusalem, Israel

Johannesburg Art Gallery, Johannesburg, South Africa

John Hansard Gallery, The University, Southampton, Great Britain

Kennedy Memorial Center, Washington, D.C.

Kettle's Yard, University of Cambridge, Cambridge, Great Britain

Leeds City Art Gallery, Leeds, Great Britain

Leicestershire Museum and Art Gallery, Leicester, Great Britain

MacRobert Arts Centre, University of Stirling, Stirling, Great Britain

Manchester City Art Galleries, Manchester, Great Britain

Marion Koogler McNay Art Museum, San Antonio, Texas

Middelheim Park, Antwerp, Belgium

Museo de Bellas Artes, Caracas, Venezuela

Museo de Bellas Artes, Valparaiso, Chile

Museu de Arte Moderna de Sao Paulo, São Paulo, Brazil

Museum Boymans-van Beuningen, Rotterdam, The Netherlands

The Museum of Modern Art, New York, New York

Museum Morbroich, Städtisches Museum Leverkusen, Leverkusen, Germany

National Art Gallery, Wellington, New Zealand

The National Gallery of Canada, Ottawa, Ontario

National Gallery of Victoria, Melbourne, Australia

The National Museum of Modern Art, Kyoto, Japan

National Museum of Wales, Cardiff, Great Britain

National Portrait Gallery, London, Great Britain

Neuberger Museum of Art, State University of New York, Purchase, New York

Niedersächsisches Landesmuseum, Hannover, Germany

Norton Simon Museum of Art, Pasadena, California

Ny Carlsberg Glyptotek, Copenhagen, Denmark

Pallant House, Chichester, Great Britain

Pepsico Collection, Purchase, New York

Pier Arts Centre, Stromnes, Orkney, Great Britain

Plymouth City Museum and Art Gallery, Plymouth, Great Britain

Portland Art Museum, Portland, Oregon

Rijksmuseum Kröller-Müller, Otterlo, The Netherlands

Royal College of Art, London, Great Britain

Royal College of Surgeons, London, Great Britain

San Francisco Museum of Modern Art, San Francisco, California

Scottish National Gallery of Modern Art, Edinburgh, Great Britain

Sheldon Memorial Art Gallery, University of Nebraska, Lincoln, Nebraska

Smith College Museum of Art, Northampton, Massachusetts

Stavanger Kunstforening, Stavanger, Norway

St. Ives Borough Council, Saint Ives, Great Britain

Storm King Art Center, Mountainville, New York

Tate Gallery, London, Great Britain

Trinity University, San Antonio, Texas

Ulster Museum, Belfast, Great Britain

United Nations, New York, New York

University of Arizona Museum of Art, Tucson, Arizona

University of California, Los Angeles, California

University of Exeter, Exeter, Great Britain

University of Lancaster, Lancaster, Great Britain

University of Liverpool Art Gallery, Liverpool, Great Britain

University of Michigan Museum of Art, Ann Arbor, Michigan

University of Minnesota, Minneapolis, Minnesota

University of Wales, Cardiff, Great Britain

Vancouver Art Gallery, Vancouver, British Columbia

Victoria and Albert Museum, London, Great Britain

Wakefield City Art Gallery, Wakefield, Great Britain

Walker Art Center, Minneapolis, Minnesota

Washington University Gallery of Art, St. Louis, Missouri

Whitworth Art Gallery, University of Manchester, Manchester, Great Britain

Wilhelm-Lehmbruck-Museum Duisburg, Duisburg, Germany

Yale Center for British Art, Yale University, New Haven, Connecticut

List of Plates

Makutu, 1969, lignum vitae, 31 x 15 x 15″
page 65

Two Faces, 1969, white marble, 19 ¾ x 24 x 24″
pages 66-67

Youth, 1970, bronze, 80 x 20 x 20″
page 69

Bridegroom, 1970, bronze, 8′ 6″ x 38 x 20″
page 71

Parent II, 1970, bronze, 94 x 20 x 30″
page 73

Ancestor II, 1970, bronze, 9′ 1 ½″ x 30 ¼ x 24″
page 75

Summer Dance, 1971, bronze, 40 x 54 x 31″
page 77

Three Forms in Echelon, 1970, white marble, 26 x 22 x 34″
page 79

Spring Form in Marble, 1970, Portuguese pink marble, 17 x 20 x 12″
page 81

Two Forms (Newborn), 1971, white marble, 22 ½ x 30 ½ x 15 ¼″
page 83

Solitary Form, 1971, white marble, 28 ½ x 24 ⅜ x 20 ⅜″
page 85

Shaft and Circle, executed 1972, cast 1973, bronze, 48 x 18 ½ x 12″
page 87

Head (Ra), 1971, bronze, 21 x 22 x 12 ¾″
page 89

Oval with Two Forms, 1972, polished bronze, 13 x 15 ¼ x 12″
page 91

Conversation with Magic Stones (Maquette), 1974, bronze, 13 ½ x 15 ¾ x 13 ¾″
page 93

Catalogue copyright © 1996 PaceWildenstein
Essay copyright © Alan G. Wilkinson
Reproduction of the sculptures, drawings and photographs of Barbara Hepworth,
and quotation from her writings copyright © Alan Bowness, Hepworth Estate.

Photography:
Prudence Cuming Associates, Limited; pages 35, 37, 45, 66, 67, 81, 87, 89, 91, 93
Sarah Harper Gifford; pages 73, 83
Ellen Page Wilson; pages 39, 49, 51, 53, 57, 61, 63, 65, 69, 71, 75, 77, 85

Design and production:
Tomoko Makiura and Paul Pollard

Library of Congress Catalog Card Number: 96-70257
ISBN: 1-878283-63-4